MARKS AND MONOGRAMS

MARKS AND MONOGRAMS OF THE MODERN MOVEMENT 1875-1930

A Guide to the Marks
of Artists, Designers
Retailers and Manufacturers
from the Period of the
Aesthetic Movement to
Art Deco and Style Moderne

MALCOLM HASLAM

Charles Scribner's Sons
New York

Produced by Cameron & Tayleur (Books) Limited, 25 Lloyd Baker Street,
London WC1X 9AT.

Published by Charles Scribner's Sons, 597 Fifth Avenue,
New York, NY 10017.

© Cameron & Tayleur (Books) Limited 1977.

Copyright under the Berne Convention.

First published in the U.K. in 1977.

Printed and bound in Great Britain.

Library of Congress Catalog Card Number 76-26189.

ISBN 0 684 14828 5.

House Editor: Elisabeth Cameron.
Designed by Ian Cameron.

Cameron & Tayleur would like to thank the following for their help and co-
operation in the preparation of this book: The Assay Office, Birmingham; The
Brooklyn Museum, New York; Cartier Ltd, London; The Chicago Historical
Society; Columbia University Library; Richard Dennis; The Fortnightly of
Chicago; Charlotte Gere; The Library of The Worshipful Company of Gold-
smiths; Gabriella Gros; Haslam & Whiteway; The Elbert Hubbard Library-
Museum; Philadelphia Museum of Art.

CONTENTS

INTRODUCTION

In compiling this book, I have attempted to collect together the marks, monograms and signatures of artists, designers and manufacturers who contributed to the radical development which took place in the applied arts over a period of some eighty years from about 1860.

This development has been called the Modern Movement and it embraced many distinct manifestations, each in a different style: Historicism, the Aesthetic Movement, Art Nouveau, the Arts and Crafts Movement, Jugendstil, Secession-stil, Expressionism, the Bauhaus, Art Deco, Neue Sachlichkeit, International Style, etc. An evolution which took so many different guises can hardly be described as a progress from A to B. It is rather a matter of contrast in appearance between the ornaments and utensils bought by Europeans and Americans today and those of a hundred and twenty years ago.

The transformation has been effected by a number of significant influences: machine production and synthetic materials, which at different times and in different places induced positive and negative reactions; the arts and crafts of the Near and Far East, Africa and Polynesia, as well as the folk cultures of the participating nations; the aesthetic theories of speculative psychology and, *per contra*, of spiritual introspection.

The very diversity of the period's styles and influences suggests that any homogeneity lies only in their representation of the crisis of the individual felt by Europeans and Americans during the same period, which begins with the publication of Darwin's *Origin of Species* and ends with the writings of Sartre and Camus. As such, all emanations of the Modern Movement are relevant to ourselves, and some of the fascination of collecting them is that they can express our own response to aspects of the contemporary world. I hope that this book will not only help collectors to identify objects but also heighten their interest in the applied arts of an epoch that is not altogether past.

So many people have helped me to compile this book that it is impossible to list them all. But at the risk of offending the others, I must record my gratitude to Ian Bennett, John Jesse and Adrian Tilbrook who have never refused the assistance I so frequently sought. I am glad to have had the benefit of expert editorial work by Elisabeth Cameron and Bettina Tayleur who have rectified many deficiencies and eliminated many errors; for those that remain the responsibility is, of course, entirely mine.

Malcolm Haslam
London, 1977

The marks are arranged in main sections according to medium: Ceramics, Glass, Metalwork & Jewelry, Graphics, Furniture & Textiles. Within each section, the arrangement is by country and then alphabetically. The order of countries is consistent from section to section, although some countries are not represented in every section. For the sake of convenience, the countries of Eastern Europe have not been dealt with separately: Hungary, as part of the old Austro-Hungarian Empire, is included under Austria; Bohemia, though now part of Czechoslovakia, has been included under Germany, because of the degree of overlap between their glass industries.

INTRODUCTION

The country under which each mark is listed is that in which the artist, designer, craftsman, manufacturer or retailer mainly worked. Where more than one medium is involved, biographical information is given under that with which the person or firm is mainly associated. Marks of artists and craftsmen are normally shown separately from those of manufacturers or retailers even where the two would appear together. Serial numbers have in most cases been excluded from marks. Names marked with an asterisk in the entries have their marks illustrated elsewhere in the book; these can be located by reference to the index. We have used the accepted spelling of names even where the artists may not have been consistent in spelling their own names.

The marks reproduced in this book have been assembled from disparate sources. Furthermore, many marks are not constant in size (particularly those which are incised, painted or woven, rather than printed, impressed or stamped). No significance should therefore be attributed to the size of any mark that is shown, nor to the relative sizes of marks in a particular section or entry.

In the case of an object bearing a mark including a legible name, it is best to refer first to the index. Otherwise, marks may be identified visually in the appropriate section. Where a person or firm has used a number of very similar marks, only one of these has normally been shown. Therefore, an object bearing a mark slightly different from that illustrated is not necessarily a fake. A final word of caution: the correctness of the mark is no guarantee that an object is genuine.

CERAMICS

BRITISH CERAMICS

ASHBY POTTERS' GUILD

Pottery established (1909) at Woodville, Derbyshire, by Pascoe H. Tunnicliff. Produced decorative and utilitarian earthenware. Guild ended in 1922. Impressed mark.

ASHTEAD POTTERS LTD

Workshops founded after World War I at Ashtead, Surrey, to provide employment for disabled servicemen. Produced tableware, inkwells, etc., and figures after models by Phoebe Stabler among others.
Printed mark (1926-36).

AULT, William (b 1841)

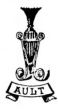

Ceramist. Trained from boyhood in Staffordshire potteries. Partner with H. *Tooth in *Bretby Art Pottery (1883-87). Subsequently established own pottery at Swadlincote, Derbyshire. Produced pottery designed by C. *Dresser from mid 1890s.
Printed, impressed or relief-moulded mark.

BAILEY, C. J. C., & Co.

Firm manufacturing porcelain and stoneware at Fulham Pottery, London, 1864-89. Produced jardinières, etc., designed by architect, J. P. Seddon; employed modellers including Edgar Kettle and R. W. Martin, eldest of *Martin Brothers. J.-C. *Cazin also made pottery at works.
Impressed monogram.

BILLINGTON, Dora May

Painter, ceramist. Studied at art schools in Hanley, Staffordshire, and South Kensington, London. Decorator for B. *Moore until 1912. Made and decorated own pottery, as well as designing for industrial firms.
Painted or incised monograms.

BRADEN, Norah (b 1901)

(i) (ii)

Ceramist. Studied drawing at Royal College of Art, London, and, in 1925, pottery under B. *Leach at St Ives, Cornwall. Worked with K. *Pleydell Bouverie (1928-36).
Impressed (i) and painted (ii) marks.

BRETBY ART POTTERY

Founded (1883) at Woodville, Derbyshire, by W. *Ault and H. *Tooth, formerly manager of *Linthorpe Pottery. Produced wide range of decorative earthenware reflecting several British and European modern styles.
Impressed mark.

BURSLEM SCHOOL OF ART

Class of pottery students made rolled clay figures in 1930s under teacher, W. *Ruscoe.
Impressed mark.

CARDEW, Michael A. (b 1901)

Ceramist. Studied under B. *Leach (1923-26). Working at *Winchcombe Pottery in Gloucestershire until 1939, and again 1941-42, made lead-glazed earthenware with slip decoration; bought pottery at Wenford Bridge, Cornwall, 1939. Subsequently worked mainly at Wenford Bridge and in Africa; made stoneware.
Impressed mark.

CARLTON WARE

See WILTSHAW & ROBINSON.

CARTER & Co.

Manufacturing firm established (1873) at Poole, Dorset. Made tiles and architectural faience. Owen Carter, son of owner, began experiments with lustre glazes c1902. Firm also made matt-glazed and painted vases. In 1921 became *Carter, Stabler & Adams.
Impressed mark.

CERAMICS

CARTER, STABLER & ADAMS

Manufacturers formed (1921) from nucleus of *Carter & Co., joined by John Adams (formerly working with B. *Moore), Truda Adams and designer H. *Stabler, whose wife Phoebe modelled figures for production at factory. Firm also produced wares decorated in enamels on white glaze in contemporary style, and limited range of coloured glaze effects in 1930s. Impressed marks.

CAZIN, Jean-Charles (1841-1901)

Painter, ceramist. From 1866, director of Ecole des Beaux-Arts at Tours (Indre-et-Loire). In London 1871-75; taught at Lambeth school of art, and made stoneware, mostly in Japanese taste, at Fulham factory of C. J. C. *Bailey. Gave advice and encouragement to *Martin Brothers. Work exhibited at Paris salon in 1895. Father of J. M. M. *Cazin.
Incised signature.

CLIFF, Clarice (1899-1972)

Designer and decorator. Born in Tunstall, Staffordshire, trained at *Burslem School of Art. Worked for Staffordshire firm of A. J. Wilkinson Ltd and subsidiary, Newport Pottery. 'Bizarre' range introduced 1928-29. Designed contemporary shapes and decoration, sometimes after original designs by artists such as Laura Knight and F. *Brangwyn.
Printed signature.

COOPER, Susie (b 1903)

Ceramist, designer. Studied at *Burslem School of Art. As well as working independently, designed shapes and decoration for A. E. Gray & Co. Ltd, Staffordshire earthenware manufacturers. Also started own company, mainly producing tableware.
Printed marks.

COX, George J.

Mortlake CJƆ

Ceramist. Studied at Royal College of Art, London. At own pottery in Mortlake, Surrey, began making ceramics close in feeling to early Chinese wares; enterprise lasted *c*1910-14. Wrote handbook for teacher and students, 1914, and went to USA in same year.
Incised mark and monogram.

CRANE, Walter (1845-1915)

Graphic artist, painter, designer. Provided designs for pottery and tiles produced by *Wedgwood factory (1867-77), *Minton factory (*c*1870), Maw & Co., and *Pilkington Tile & Pottery Co. in early 20th century. Prominent in Arts & Crafts Movement, founder member and first president of Art Workers' Guild; chairman in 1880s, and again 1895-1915, of Arts & Crafts Exhibition Society. In 1890s taught in Manchester and subsequently Reading; principal of Royal College of Art, London. Also designed tapestries for W. *Morris & Co., furniture, wallpapers, book illustration, etc.
Painted monogram.

DALTON, William B.

WB

Painter, designer, ceramist. Principal of Camberwell School of Arts & Crafts, London, 1899-1919; encouraged and became involved in instruction of pottery. Worked independently as potter from 1919. Emigrated to USA in 1941.
Incised monogram.

DELLA ROBBIA POTTERY

D R

Established (1894) at Birkenhead, Cheshire, by sculptor Conrad Dressler and painter Harold Rathbone. Made useful and ornamental wares with *sgraffito* decoration and painted, mostly in style of Italian *maiolica* or Isnik pottery. Closed 1906.
Painted or incised mark.

DE MORGAN, William Frend
(1839-1917)

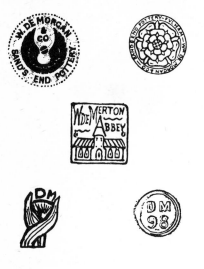

Painter, designer. Trained as painter at Royal Academy Schools, London. Worked as stained glass artist for W. *Morris & Co. Started experiments with lustre glazes in 1869; established own pottery and decorating studio in Chelsea, London, in 1872, making vases, tiles, etc., decorated with own designs in lustre or Isnik colours. Moved in 1882 to Merton Abbey, sharing premises with William Morris, and in 1888 to Fulham. From 1892, spent part of each year in Italy; retired from pottery in 1905. Works closed in 1907.
Impressed marks.

DOULTON & Co.

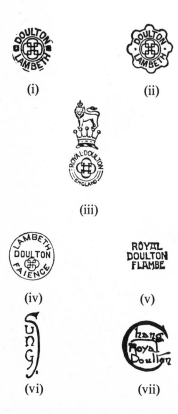

Factory established (c1815) at Lambeth, London, as Doulton & Watts. In 1858, Watts interest bought by Henry Doulton. From 1865, partly at instigation of John Sparkes, headmaster of local art school, produced artistic stoneware decorated with applied clay and incised designs by students from school. Other lines introduced later include painted earthenware (Doulton Faience). Figures and high-relief plaques modelled by George Tinworth; grotesques modelled by Mark V. Marshall. From 1878, firm also operated factory at Burslem, Staffordshire, which produced 'Flambé' high temperature glazed ware from c1905.
Impressed (i-iii), printed (iii-v) and painted (vi, vii) marks.

DRESSER, Christopher (1834-1904)

Architect, designer. Entered School of Design, London, in 1847. Made special study of botany in relation to design. Travelled widely, visiting Vienna (1873), Japan and USA (1876-77), Paris (1878), etc. Wrote theoretical books on design, including study of Japanese art. Designed glass, metalwork, textiles, etc., as well as ceramics for *Linthorpe Pottery (artistic director there, 1879-82), and for pottery of W. *Ault in 1890s. Also sold decorative designs to *Minton factory. Impressed facsimile signature.

ELTON, Sir Edmund (d 1920)

Ceramist. Started making pottery on own estate at Clevedon, Somerset, in 1879. Jugs and vases, often in bizarre shapes, decorated with stylized flowers, dragons, etc., modelled in slip in low relief on a marbled ground. From c1900 developed crackled glaze in gold and platinum lustre.
Painted mark.

FORSYTH, Gordon Mitchell
(1879-1952)

Decorator, ceramist. Trained at Royal College of Art, London. Art director of *Minton factory (1903-05). From 1906, as art director at *Pilkington Tile & Pottery Co., designed and decorated lustreware. Principal of Stoke-on-Trent art schools, Staffordshire, from 1920.
Painted mark.

HAMADA, Shoji (b 1892 or 1894)

Ceramist. Japanese; met B. *Leach in Japan and with him established pottery (1920) at *St Ives. Returned to Japan in 1923. On subsequent visit to Britain, again worked at St Ives. Influenced by Korean and early Chinese ceramics. Impressed mark.

KEYES, Phyllis

Ceramist. Made pottery during 1930s, including tin-glazed ware painted by artists such as Simon Bussy, Vanessa Bell and Duncan Grant.
Incised or painted mark.

LEACH, Bernard H. (b 1887)

BL:

(i)

(ii)

Graphic artist, ceramist. Born in Hong Kong, brought up in Tokyo. Studied engraving at Slade School of Art, London. Returned to Japan, learnt to make pottery and studied Oriental, especially Korean, ceramics. Came to Britain in 1920, and established pottery at St Ives with assistance of S. *Hamada. Made stoneware in style of Korean and early Chinese wares and slipware in style of English work of 17th and 18th centuries.
Impressed (i) and painted (ii) marks.

LINTHORPE POTTERY

LINTHORPE

Founded (1879) at Middlesbrough, Yorkshire, by John Harrison, with H. *Tooth as manager and C. *Dresser as artistic director. Specialized in original shapes and variety of soft-coloured glaze effects; sometimes incised or painted decoration. Production ended c1890.
Impressed mark.

MANNERS, Erna

Ceramist. Working in first quarter of 20th century, made plates and vases decorated in enamels with designs of stylized flowers, etc. Also made figures.
Painted monogram.

MARTIN BROTHERS

R W Martin London

Artist potters, four brothers, set up workshops (1877) at Southall, Middlesex. Eldest, Robert Wallace (1843-1924), trained as sculptor at Royal Academy Schools, London; fired terracotta statues at factory of C. J. C. *Bailey, c1870-72. Walter, who studied under J.-C. *Cazin at Lambeth art school, and Edwin

worked briefly for *Doulton & Co. Brothers carried out experiments at home in Fulham, London, before using Bailey's kilns. When partnership at Southall established, retail shop opened in Holborn, run by fourth brother, Charles. Specialized in modelled and incised stoneware, including grotesque figures of birds and monsters. Incised designs inspired by Renaissance ornament, Japanese art, and flora and fauna of environment. From *c*1895 made pots with abstract decoration inspired by Japanese folk pottery. After deaths of Walter (1912) and Edwin (1915), production virtually ended.
Incised marks.

MINTONS Ltd

Manufacturers of porcelain and earthenware at Stoke-on-Trent, Staffordshire; founded 1793. In 1871, Art-Pottery Studio set up in London under artistic direction of painter, William S. Coleman (1829-1904), where art school students and amateurs were provided with kiln facilities for painting china. Firm produced line *c*1900 in Art Nouveau style, designed by Leon Solon and Edward Wadsworth. Fine tableware staple product of factory.
Printed marks.

MOORCROFT, William, Ltd

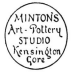

Pottery workshops established (1913) at Burslem, Staffordshire by William Moorcroft (1872-1945) who had previously worked for James Macintyre & Co. Produced wide range of decorative ceramics.
Painted mark.

MOORE, Bernard (1853-1935)

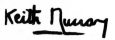

Ceramist. 1870-1905: ran porcelain manufacturers, Moore Bros of Longton, Staffordshire, with brother. When partnership ceased production, set up own kiln at Stoke-on-Trent, Staffordshire; experimented with *flambé* and other Oriental glaze effects. Also made *flambé* glazed ware decorated with gilding and enamels by group of artists including John Adams (*Carter, Stabler & Adams) and D. *Billington.
Painted marks.

MORTLAKE POTTERY

See COX, G. J.

MURRAY, Keith (b 1893)

Architect, designer. For biography see GLASS. Designed ceramics for *Wedgwood.
Printed signature.

MURRAY, William Staite (1881-1962)

Painter and ceramist. Studied at Camberwell School of Arts & Crafts and started making pottery (*c*1915) with painter Cuthbert Hamilton, working as *Yeoman Potters. Set up alone at Rotherhithe, Surrey, in 1919, making *flambé* glazed stoneware. After meeting B. *Leach and S. *Hamada (*c*1921) worked more closely in style to Korean and early Chinese ceramics. Brushed decoration is related to contemporary British painting; he exhibited jointly with Ben Nicholson, Christopher Wood and others. Later work became more sculptural.
Impressed mark.

NORTON, Wilfred and Lilly

Sculptors, ceramists. Husband and wife who worked independently and in collaboration making pottery figures in 1920s and 1930s.
Incised monogram.

OMEGA WORKSHOPS

Workshops started (1912) by painter and critic, Roger Fry, to provide remuneration for avant-garde artists. Fry learnt to make pottery at Camberwell School of Arts & Crafts, London, and at factory of *Carter & Co. Blanks also bought from factories for decoration by Duncan Grant, Vanessa Bell and other painters.
Incised or painted mark.

PILKINGTON TILE & POTTERY Co.

Established (1892) at Clifton Junction, Lancashire, under direction of William Burton (1863-1941). First produced tiles (designed by C. F. A. Voysey, L. F. Day and W. *Crane, among others) and architectural wares. Vases decorated with coloured and aventurine glazes made from 1897 and lustre ware from 1903. Some designs for lustre decoration by W. Crane. Artist decorators included G. *Forsyth, art director from 1906. Lustreware marketed as 'Lancastrian', later 'Royal Lancastrian'.
Printed or impressed marks.

PLEYDELL BOUVERIE, Katharine
(b 1895)

Ceramist. Studied at Central School of Art, London, and under B. *Leach. In 1925, set up own studio at Coleshill, Wiltshire, which she shared with N. *Braden, making stoneware, decorated with ash glazes derived from wood and plants.
Impressed monogram.

POWELL, Alfred

Designer, decorator. With wife, L. *Powell, made tin-glazed earthenware decorated with lustre or enamels in designs of landscapes, stylized foliage, or heraldic motifs. Also painted china, in same style, for *Wedgwood factory, and trained decorators for firm. Worked c1905-c1935.
Painted mark.

POWELL, Louise

Designer, decorator. Grand-daughter of china painter, Emile Lessore. Made and decorated pottery in collaboration with husband A. *Powell (married *c*1909). Painted mark.

RUSCOE, William

Ceramist. Worked in Staffordshire potteries from early age. In 1920s and 1930s taught at *Burslem School of Art. Noted for rolled-clay figures.
Incised or painted monograms.

RUSKIN POTTERY

See TAYLOR, W. H.

ST IVES POTTERY

Established at St Ives, Cornwall by B. *Leach and S. *Hamada in 1920. Impressed marks.

SIMPSON, W. B., & SONS

Firm of interior decorators founded (1873) in London. Produced painted tiles in Japanese taste which prevailed during Aesthetic Movement.
Impressed mark.

TAYLOR, William Howson
(1876-1935)

(i)

(ii)

(iii)

Ceramist. Son of principal of Birmingham School of Art, where he studied. Worked briefly for Howson, Staffordshire pottery owned by maternal relatives. Established own workshop, Ruskin Pottery, in 1897 at West Smethwick, Birmingham; developed range of *flambé* glazes by *c*1902. Also decorated pottery with mottled lustre and, in 1920s, matt glaze effects.
Painted (i) and impressed (ii, iii) marks.

TOOTH, Henry

Painter, ceramist. Manager at *Linthorpe Pottery 1879-82; founded *Bretby Art Pottery with W. *Ault, 1883. Impressed monogram.

VYSE, Charles (d 1968)

Sculptor, ceramist. Studied modelling at Hanley School of Art, Staffordshire, and sculpture in London. From c1919, worked at own studio in London, making ceramic figures and stoneware vases, jugs, bowls, etc., either in imitation of early Chinese ceramics or decorated with contemporary designs in iron and cobalt. Painted monogram.

WATCOMBE POTTERY

Established (1869) near Torquay, Devon. Made terracotta in classical shapes austerely decorated with turquoise enamels in geometrical designs. Also painted, *sgraffito* and glazed wares. Printed mark.

WEDGWOOD

WEDGWOOD

Manufacturers founded (1759) by Josiah Wedgwood at Burslem, Staffordshire. Etruria works at Barlaston, Staffordshire, set up in 1769. From c1880, produced slip-painted china decorated with abstract designs, or bird and flower motifs of Japanese inspiration. A. and L. *Powell commissioned to decorate china with lustre designs, c1905-c1935. 'Dragon' and 'Fairyland' lustre-painted wares produced from c1932 under direction of decorator, Daisy Makeig-Jones. Victor Skellern, art director from 1935, commissioned designs for tableware from K. *Murray, Eric Ravilious, and models for figures from sculptors Roy Smith, John Skeaping, Arnold Machin. Impressed or printed marks.

WELLS, Reginald Fairfax (1877-1951)

COLDRVM

Sculptor, ceramist. Successful sculptor; turned to pottery c1908, first working at Wrotham, Kent, and from c1910 at Chelsea, London. Early work influenced by 17th century slip-decorated Wrotham ware; quickly adopted styles of Chinese ceramics. Moved to Storrington, Sussex, in 1920s. Called work 'Coldrum' ware and, later, 'Soon' ware.
Impressed marks.

WILTSHAW & ROBINSON

Manufacturers at Stoke-on-Trent, Staffordshire, producing range of china known as 'Carlton Ware', including lustreware printed with oriental designs, during first half of 20th century.
Printed marks.

WINCHCOMBE POTTERY

Pottery at Winchcombe, Gloucestershire, rented by M. *Cardew 1926-39.
Impressed mark.

WREN, Denise K. (b 1891)

Ceramist. Born in Australia, moved to Britain and studied under designer, Archibald Knox, at Kingston-upon-Thames art school, 1907-11. Started making pottery in Kingston (1911) and in 1919 set up own studio at Oxshott, Surrey.
Incised mark.

YEOMAN POTTERS

Collaboration between W. S. *Murray and painter Cuthbert Hamilton. At studio in Yeoman's Row, London, made pottery decorated in enamels with abstract Vorticist designs.
Incised mark.

AREQUIPA POTTERY

Established (1911) at Fairfax, California, in conjunction with tuberculosis sanatorium for women. Patients carried out decoration of pots produced under direction of F. *Rhead (1912-13), Albert L. Solon (1913-16), and Fred H. Wilde, who stayed until closure of pottery in 1918.
Painted, incised or impressed marks.

AVON POTTERY

AVON

Art pottery producing high quality wares (1886-88) at Cincinnati, Ohio; founded by ceramic chemist, Karl Langenbeck (1861-1938), whose work was similar in style to early production at *Rookwood Pottery of childhood friend, Maria Longworth Nichols, and who was later employed at *Grueby Pottery.
Impressed mark.

BILOXI ART POTTERY

G. E. OHR,
BILOXI.

Founded (c1880) at Biloxi, Mississippi, by George E. Ohr (1857-1918). Ohr generally worked without assistant other than son, Leo, producing thin-walled ware in bizarre shapes.
Impressed mark and incised signature.

BROUWER, Theophilus A.
(1864-1932)

Brouwer

Artist potter and craftsman in wood, metal, etc.; founder of *Middle Lane Pottery; employing only two assistants, achieved lustre, crystalline and other glaze effects. After sale of Middle Lane Pottery, opened Brouwer Pottery at Westhampton, New York.
Incised signature.

BYRDCLIFFE POTTERY

Founded (*c*1905) by Edith Penman and Elizabeth R. Hardenburgh as part of arts and crafts colony started by Ralph Radcliffe Whitehead. Products characterized by bright colouring of glazes.
Impressed mark.

CHELSEA KERAMIK ART WORKS

(i)

(ii)

Pottery established (1872), when James Robertson and son George joined other two sons, Alexander W. and H. C. *Robertson who were working in Chelsea, Massachusetts. Produced faience, etc. H. C. Robertson developed 'oxblood' glaze and (in 1886) crackle glaze achieved. Alexander Robertson left (1884) for California, where later founded Roblin Pottery. Production ceased in 1889.
Impressed mark (i) and initials of Alexander W. Robertson (ii).

CLIFTON ART POTTERY

CLIFTON
POTTERY
NEWARK, N.J.

(i)

CLIFTON

(ii)

Established (1905) at Newark, New Jersey, by chemist Fred Tschirner and William A. Long, co-founder (1892) of *Lonhuda Pottery. Two main types of ware produced: 'Crystal Patina', and 'Indian Ware' (adapted from forms and decoration of American Indian pottery). Ceased to make art pottery in 1911, afterwards specializing in production of tiles.
Incised (i) and impressed (ii) marks.

COWAN, R. Guy (1884-1957)

(i)

(ii) (iii)

Ceramist, one of family of potters at East Liverpool, Ohio. Studied under Charles F. Binns at New York School of Clay Working at Alfred University. Taught at Technical High School in Cleveland, Ohio, setting up own studio in Cleveland, 1912. In 1920, moved workshops to Rocky River, Ohio. Worked with several assistants to produce wide range of ceramics including porcelain figures, vases, etc. Pottery closed in 1931.
Incised (i, ii) and impressed (iii) marks.

DALLAS POTTERY

Chinaworks in Cincinnati, Ohio, bought by Frederick Dallas in 1865. Factory adapted (1879) at expense of M. L. McLaughlin (*Losanti Pottery) and M. L. Nichols (*Rookwood Pottery), for production of faience painted by members of Cincinnati Pottery Club. Pottery closed in year following Dallas's death in 1881.
Impressed mark.

DEDHAM POTTERY

(i)

(ii)

Pottery, established (1891) in Chelsea, Massachusetts, under supervision of H. C. *Robertson and trading as Chelsea Pottery, moved to Dedham, Massachusetts in 1895 and changed name accordingly. Continued production of 'Cracqule Ware', tableware decorated under crackle glaze developed by Robertson; also made vases with *flambé* and 'volcanic' glazes. Factory closed in 1943.
Impressed (i) and printed (ii) marks.

DENVER CHINA & POTTERY Co.

Founded (1901) at Denver, Colorado, by William A. Long (1844-1918), previously co-owner of *Lonhuda Pottery. 'Denaura' range of vases decorated with floral motifs treated in Art Nouveau manner in low relief. Merged with Western Pottery Manufacturing Co. in 1905.
Impressed marks.

FRACKELTON, Susan Stuart Goodrich (1848-1932)

Ceramist. Daughter of brickmaker; in 1883 established Frackelton China Decorating Works in Milwaukee, Wisconsin. As well as developing mineral colours for china painting, made salt-glaze stoneware.
Incised monogram.

FULPER POTTERY

Established (1814) at Flemington, New Jersey, by Samuel Hill. Bought (1862) by employee A. Fulper, who was succeeded after death in 1881 by sons George W., William H. and Edward B. Fulper. Production of art pottery was not undertaken until introduction of 'Vasekraft' range in 1909. Impressed or printed mark.

GRAND FEU ART POTTERY

Established c1912 by Cornelius W. Brauckman (1864-1952) in Los Angeles, California. Made stoneware decorated with high temperature glaze effects. Impressed marks.

GRUEBY POTTERY

Founded (1897) at Boston, Massachusetts, by William H. Grueby (1867-1925), formerly producer of architectural faience, with George Prentiss Kendrick, craftsman in metal-work, as designer. Noted for matt glazes; ceased production of art pottery in 1911. Impressed mark.

JERVIS, William Percival (1849-1925)

Ceramist. Born in Stoke-on-Trent, Staffordshire, England; was making pottery in USA by 1898. Concerned with various art potteries including *Rose Valley, Corona (New York), and Craven (East Liverpool, Ohio); organized own workshops (1908) at Oyster Bay, New York, where F. *Rhead briefly engaged. Incised marks.

LANGENBECK, Karl

See AVON POTTERY.

LONHUDA POTTERY

Founded (1892) at Steubenville, Ohio, by William A. Long (founder of *Denver Pottery), W. H. Hunter and Alfred Day. Produced faience decorated in manner of *Rookwood Pottery. Joined (1893) by Laura A. Fry (1857-1943), who had worked at Coultry and Rookwood potteries in Cincinnati. Pottery purchased in 1894 by S. A. Weller (founder of *Weller Pottery) and moved to Zanesville, Ohio.
Impressed marks.

LOSANTI POTTERY

Lo'santi

L M⚊L

Founded (1898) at Cincinnati, Ohio, by Mary Louise McLaughlin (1847-1939), who had previously developed decorative technique used in manufacture of Cincinnati faience, e.g. at *Dallas Pottery (1879-82) and by T. J. *Wheatley & Co. Produced hard-paste porcelain, usually decorated with carving or piercing, until 1906, when M. L. McLaughlin abandoned ceramics.
Painted marks and initials.

MARBLEHEAD POTTERY

Pottery started (1904) at Marblehead, Massachusetts, as one of group of craft workshops, Handcraft Shops, intended to provide occupational therapy for convalescent patients; began operating independently within first year. Under supervision (and, from 1915, ownership) of Arthur E. Baggs (1886-1947), produced vases, lamps, etc., noted for simplicity of form and decoration; tin-glazed tableware introduced 1912. Pottery closed in 1936.
Printed mark.

McLAUGHLIN, Mary Louise

See LOSANTI POTTERY.

MERRIMAC POTTERY Co.

Name given (1902) to Merrimac Ceramic Co. when firm's interest switched from utility to artistic wares under continuing management of Thomas S. Nickerson. Production ceased when works at Newburyport, Massachusetts, burnt down in 1908.
Impressed mark.

MIDDLE LANE POTTERY

Studio pottery started (1894) by T. A. *Brouwer at East Hampton, New York. Small production includes iridescent wares, often press-moulded or cast in naturalistic forms. Jawbones of whale, forming entrance to pottery, incorporated in mark.
Incised and impressed mark.

NEWCOMB POTTERY

Pottery developed from classes held for lady students of Newcomb College (Tulane University, Louisiana) at New Orleans Art Pottery. In 1895, college had own workshops. Production primarily vases, etc., decorated with stylized floral motifs.
Painted mark.

OHR, George E.

See BILOXI ART POTTERY.

OVERBECK POTTERY

Art pottery established (1911) by four Overbeck sisters at their home in Cambridge City, Indiana. Specialized in glaze inlays and carved decoration.
Incised mark.

OWENS, J. B.

Manufacturers, founded (1885) at Roseville, Ohio; moved to Zanesville, Ohio, in 1892. Produced wide variety of art pottery, including painted and lustre wares, between 1895 and 1906.
Printed mark.

PAUL REVERE POTTERY

Pottery started (1906) as one of activities offered by 'Saturday Evening Girls' club teaching crafts to immigrant girls in Boston, Massachusetts; name adopted in 1908. Moved to Brighton, Massachusetts, in 1915. Specializing in painted and incised wares, produced wide variety of decorative ceramics.
Impressed marks.

PEWABIC POTTERY

Founded (1903) by Mary Chase Perry (Stratton) at Detroit, Michigan. Specialized in handmade pottery decorated with coloured glazes, and tile murals.
Impressed mark.

RHEAD, Frederick Hurten
(1880-1942)

Ceramist. Born in Staffordshire, England, was art director of pottery in home town, Hanley, at age of 20. Arrived in USA in 1902 and worked as assistant to W. *Jervis. Then worked for *Weller and *Roseville potteries, rejoining Jervis in 1908. After teaching at *University Pottery for two years, worked at *Arequipa Pottery (1912-13). Subsequently established own pottery at Santa Barbara in southern California. Specialized in inlay and sgraffito decorative techniques. Left California in 1917, returning east to work on research in Zanesville, Ohio.
Impressed mark.

ROBERTSON, Hugh Cornwall
(1844-1908)

Ceramist. At *Chelsea Keramic Art Works, experimented with and finally achieved 'oxblood' glaze; also started work on crackle glaze later used at *Dedham Pottery.
Initials.

ROBINEAU, Adelaide Alsop
(1865-1929)

Painter and ceramist. In 1899, with husband Samuel Edouard Robineau, founded practical magazine for china decorators, *Keramic Studio*. Soon afterwards, started experimenting initially with earthenware and then porcelain. Specialized in carved pieces and in matt glazes. Worked at *University City Pottery.
Impressed mark.

ROOKWOOD POTTERY

Art pottery founded (1880) by Maria Longworth Nichols (Storer) at Cincinnati, Ohio. Became famous for 'Standard' ware, developed from Cincinnati faience produced by T. J. *Wheatley & Co. and others at the time. First chemist (from 1885) was Karl Langenbeck, who later established *Avon Pottery. Decorators include Albert R. Valentien, A. *Van Briggle, M. L. McLaughlin (*Losanti Pottery), Kataro Shirayamadani, and Matthew A. Daly.
Impressed monogram (flame added for each year, 1884-1900; subsequently, Roman numeral indicating date incorporated under monogram).

ROSE VALLEY POTTERY

Workshops established (1904) under W. *Jervis at Rose Valley Association, artists' colony in Pennsylvania.
Raised mark.

ROSEVILLE POTTERY Co.

Firm of manufacturers founded (1890) at Roseville, Ohio, occupying works previously used by J. B. *Owens pottery. Two factories in Zanesville, Ohio, later acquired. 'Rozane' (slip-painted) ware, firm's first art pottery, introduced in 1900 and followed by several other lines. Success of pottery continued until 1940s.
Impressed mark.

TIFFANY POTTERY

Experiments with pottery carried out by *Tiffany Studios at Corona, New York, from 1898. Production, offered commercially from 1905, includes bronze plated wares; ceased during World War I. Incised mark.

UNIVERSITY CITY POTTERY

Founded (1910) at University City, Missouri, by Edward G. Lewis. Staff included T. *Doat, E. Diffloth (from *Boch Frères), F. *Rhead and A. *Robineau and her husband. Porcelain of highest quality produced, winning Grand Prix at Turin exhibition, 1911. By following year, however, most of staff left because of Lewis's administrative difficulties. Production ceased after Doat's return to France in 1915. Printed mark incorporating Doat's monogram.

VAN BRIGGLE, Artus (1869-1904)

Ceramist. Studied under Karl Langenbeck at *Avon Pottery and, in 1886, joined *Rookwood Pottery. Sent to Europe to study, won prizes at Académie Julian in Paris. Returned to USA in 1896, and worked for Rookwood until forced by tuberculosis to move to Colorado Springs in 1899. There set up own pottery, in production from 1901, and continued after Van Briggle's death by wife, Anne. Impressed mark.

VOLKMAR, Charles (1841-1914)

Painter, ceramist. Studied art in Baltimore and in France. Worked in 1876 with potter near Fontainebleau (Seine-et-Marne), then at studio of T. *Deck and factory of *Haviland & Co. Returned to USA (1879), building own kiln and studio at Tremont, New York, by 1882. Later moved to Corona, New York. Produced work decorated in *barbotine* technique and, later, plain matt glazes. In 1903, with son, Leon, set up Volkmar

Kilns at Metuchen, New Jersey. Father and son both taught; Leon (1879-1959) head of pottery department at Pennsylvania Museum School of Industrial art from 1903.
Incised marks.

WALLEY, William Joseph (1852-1919)

W J W

Ceramist. Son of Ohio potter, went to learn craft at *Minton factory, before age of 10. Returned to USA, finally setting up workshops (after failure of several ventures) at West Sterling, Massachusetts. Ware marketed through Arts & Crafts Society in Boston.
Impressed initials.

WALRICH POTTERY

Founded at Berkeley, California, in 1922 by James and Gertrude Wall. Pottery ended in 1930.
Impressed mark.

WANNOPEE POTTERY

Name assumed by New Milford Pottery Co. (founded, 1887, at New Milford, Connecticut) after reorganization in 1892. Under management of A. H. Nobel, produced 'Scarabronze' ware in Art Nouveau shapes covered with metallic glazes.
Impressed mark.

WELLER POTTERY

(i)

SICARDO
WELLER.

(ii)

Weller
Rhead
Faience

(iii)

Pottery founded (1872) by Samuel A. Weller at Fultonham, Ohio. Began making art pottery at works in Zanesville, Ohio, in 1893 and acquired *Lonhuda Pottery in following year. Produced variety of lines under trade names which included 'Louwelsa' and 'Sicardo' (lustreware developed by Jacques Sicard, former employee of C. *Massier). F. *Rhead also worked for pottery.
Impressed (i, ii) and incised (iii) marks.

WHEATLEY, T. J. & Co.

T.J.Wheatley

Art pottery founded at Cincinnati, Ohio, in 1880 by Thomas Jerome Wheatley (1853-1917) formerly associated with Cincinnati School of Design and Coultry Pottery in Cincinnati.
Incised signature.

ZANESVILLE ART POTTERY

LA MORO

Manufacturers; founded 1896, traded until 1900 as Zanesville Roofing Tile Co. Hand painted, slip-decorated wares, known as 'La Moro', introduced c1908. Impressed mark.

FRENCH CERAMICS

AVISSEAU, Charles-Jean (1796-1861)

Ceramist. In 1829, set up workshop at Tours (Indre-et-Loire), making earthenware in style of Bernard Palissy. Probably earliest studio potter.
Incised signature and monogram.

BARK, Nils Ivan Joakim Graf (1863-1930)

Painter and ceramist. Born in Malmö, Sweden, of aristocratic Swedish family, grew up in Paris. Before 1900. went to St Amand-en-Puisaye (Nièvre) and there learnt to make pottery from J. *Carriès, working in similar style.
Incised mark.

BIGOT, Alexandre (1862-1927)

GRES de BIGOT

Ceramist. Studied chemistry; inspired by Oriental pottery seen in Paris Exhibition (1889) to take up ceramics. At first, worked at home in Orléans (Loiret); later moved to Paris and established workshop. Produced glazed stoneware, including many figurative pieces modelled by leading sculptors.
Incised and impressed marks.

CARRIÈRE, Ernest (1858-1908)

ERNEST CARRIÈRE

Painter and modeller. Worked for firm of T. *Deck from c1890. Shortly before death appointed artistic director at *Sèvres factory.
Incised signature.

CARRIÈS, Jean (1855-94)

Sculptor, ceramist. Trained in sculpture at Ecoles des Beaux-Arts at Lyons (Rhône) and Paris. During military service, made figures in terracotta. After seeing Japanese stoneware at Paris Exposition in 1878, moved to pottery area near Nevers (Nièvre) and started work in stoneware. Subsequently built kiln in St Amand-en-Puisaye; also worked at Château Montriveau. As well as stoneware following Japanese style, made stoneware sculpture; work includes figures, half animal, half human in form, and grotesque masks.
Incised mark.

CAZIN, J. M. Michel (1869-1917)

JM MICHEL CAZIN

Sculptor and ceramist. Son of J.-C. *Cazin. Made stoneware decorated with flowers, fruit etc. in relief. Work shown in exhibitions from 1897.
Incised mark.

CHAPLET, Ernest (1835-1909)

Ceramist. Studied with porcelain decorator Emile Lessore and at *Sevres factory. From 1857 to 1874, worked for firm of Laurin at Bourg-la-Reine (Hauts-de-Seine) and introduced *barbotine* decorative technique there (1871-72). Subsequently worked for *Haviland & Co., first making faience at Auteuil workshop under Félix Bracquemond, and then as director of studio in Rue Blomet, where he introduced stoneware painted in slip and, in 1885, took control of workshop. From 1885, cooperated with Paul Gauguin in production of ceramics. After moving to Choisy-le-Roi (Seine) in 1887, concentrated on high-temperature cuprous glaze effects.
Impressed mark while working for Haviland & Co. at Rue Blomet.
Used rosary alone, usually painted, when working independently.
(*Chaplet* = rosary.)

CHAUVIGNÉ, Auguste (1829-1904)

Painter, ceramist. Studied pottery under C. *Avisseau and, like him, established workshop producing earthenware in style of Bernard Palissy.
Painted monogram.

CHERET, Joseph (1838-94)

Joseph **Cheret**

Sculptor. Younger brother of Jules *Cheret. Studied under sculptor, Albert Carrier-Belleuse, whose daughter he married. Designed furniture and glass before modelling for *Sèvres factory (from 1887).
Incised signature.

DALPAYRAT, Pierre-Adrien
(1844-1910)

Ceramist. Between 1876 and 1888, ran
pottery in Monte Carlo. In 1889
established own workshop at Bourg-la-
Reine (Hauts-de-Seine) in collaboration
with sculptor, Alphonse Voisin-
Delacroix, who modelled several pieces.
Made stoneware decorated with *flambé*
glazes.
Incised and impressed marks.

DAMMOUSE, Albert-Louis (1848-1926)

Sculptor, ceramist, glass artist. Son of
modeller at *Sèvres factory, studied
sculpture and, subsequently, *pâte-sur-
pâte* technique under modeller and
decorator, Marc-Louis Solon. In 1871, set
up studio at Sèvres (Hauts-de-Seine),
making porcelain to his own designs.
Worked in 1880s for *Haviland & Co.
studio in Rue Blomet, Paris; learnt use of
stoneware from E. *Chaplet. Subse-
quently produced stoneware as well as
porcelain in own studio. In 1892, built his
own kiln.
Painted mark.

DECK, Théodore (1823-1908)

T-H·DECK·

Ceramist. Studied in Strasbourg, Vienna
and Düsseldorf. Worked as stove maker
in France, Germany and Austria;
foreman (1847-48) at firm of stove makers
in Paris. Modelled sculpture in terracotta
and again worked as stove maker (1851-
55), before setting up own workshop in
Paris; began association with artists who
decorated at the studio pottery made
there. Exhibited painted wall-plates at
industrial art exhibition in Paris (1861).
Also produced pottery painted in Isnik

style and, in 1884, exhibited *flambé* glazed porcelain; celadon glaze also developed. Book *La Faience* published 1887; in same year became art director at *Sèvres factory, remaining there until death.

Impressed marks. Portrait mark used from *c*1880.

DECOEUR, Emile (1876-1953)

(i)

(ii)

Ceramist. Worked with E. *Lachenal from 1890 and exhibited work independently from 1901. Worked (1903-06) with F. *Rumèbe, and moved in 1907 to Fontenay-aux-Roses (Seine). 1908-14: made porcelain and stoneware, several pieces modelled by sculptors. After World War I, specialized in simple forms with limited geometrical ornament and glaze effects. Designed shapes for *Sèvres factory from 1939 and became firm's artistic consultant in 1942; retired from post in 1948.

Incised signature (i) and painted monogram (ii).

DÉCORCHEMONT, François-Emile (1880-1971)

Painter, glass artist and ceramist. For biography see GLASS.
Impressed mark.

DE FEURE, Georges (1868-1928)

Painter, graphic artist, poster artist, designer. For biography see GLASS. Designed porcelain tableware for Samuel Bing's shop, La Maison de l'Art Nouveau.
Printed signature.

DELAHERCHE, Auguste (1857-1940)

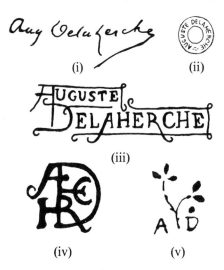

(i) (ii)

(iii)

(iv) (v)

Ceramist. Studied at Ecole des Beaux-Arts, Paris; worked in evenings, first in stained-glass studio, then for firm of religious metalworkers. In 1883 inspired by book on Bernard Palissy, took up pottery. Took over studio of E. *Chaplet in Rue Blomet, Paris, in 1886. Moved to Armentières (Nord) in 1894 and the following year began production of porcelain in addition to stoneware, which he was already making. Used *flambé* glazes, and sometimes decorated work with floral designs.
Incised (i), impressed (ii-iv) and painted (v) marks.

DE SAINT MARCEAUX, René (1845-1915)

MARCEAVX

Sculptor, modeller. Work includes figures modelled for reproduction in porcelain at *Sèvres factory.
Moulded signature.

DESMANT, Louis

Ceramist. Exhibited faience and stoneware from 1892. After 1913 worked at Subles in Normandy, concentrating on lustre glazes; series of pieces painted in lustre with scenes from Bayeux tapestry.
Incised mark.

DOAT, Taxile (1851-after 1939)

Ceramist. Studied at Ecole des Arts Décoratifs, Limoges, and Ecole des Beaux-Arts, Paris. In 1877 started work for *Sèvres factory. From 1892 had own workshop, at first in Paris, then at Sèvres (Hauts-de-Seine). In 1905 wrote *Grand Feu Ceramics* (published at Syracuse, New York). Taught at *University City Pottery from 1909 to 1911, returning to Paris in 1914. Worked in porcelain and stoneware, either with *pâte-sur-pâte* decoration or in vegetable forms covered with *flambé* glazes.
Incised monogram.

DUFRÊNE, Maurice (1876-1955)

M. DUFRENE

Designer. Studied at Ecole des Arts Décoratifs, Paris, until 1900, then worked for La *Maison Moderne. Taught at municipal art school in Paris from 1913, continuing to design furniture, metal-work and ceramics.
Printed signature.

FIX-MASSEAU, Pierre-Félix (1869-1937)

Fix. MASSEAU

F Masseau

Sculptor, modeller. Made figures and decorative hollow ware for reproduction in stoneware by A. *Bigot.
Incised signatures.

GALLÉ, Emile (1846-1904)

Artist in glass, ceramics and furniture.
For biography see GLASS.
Painted and impressed marks.

GLATIGNY, L'ATELIER DE

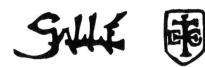

French art pottery manufacturers, in production from 1890s.
Impressed mark.

GRITTEL, Emile (1870-1953)

Medallist, ceramist. Through G. *Hoentschel, met J. *Carriès, becoming his pupil and working in Carriès's style. Ran own studio in Clichy, Paris; also worked with E. *Lion at St Amand-en-Puisaye (Nièvre).
Incised signature.

GRUBER, Jacques (1870-1936)

J.Gruber

Designer and artist craftsman. Primarily artist in glass, working for *Daum Frères, also designed pottery. Lived and worked in Nancy (Meurthe-et-Moselle).
Painted signature.

GUIMARD, Hector (1867-1942)

Architect, designer. Studied at Ecole des Arts Décoratifs and Ecole des Beaux-Arts, Paris. Designed several notable Art Nouveau buildings and entrances to Paris Métro. Also designed ceramics for *Sèvres, furniture and metalwork. Impressed monogram.

HAVILAND & Co.

HAVILAND & C°

(i)

(ii)

China manufacturers, founded (1842) at Limoges by David Haviland, who was succeeded in 1871 by sons Charles and Théodore. In 1873 Charles Haviland started studio at Auteuil, Paris, placing in charge decorative and graphic artist Félix Bracquemond. Studio produced earthenware decorated with *barbotine* painting in style of Barbizon school of landscape painters. Artists included E. *Chaplet and E. *Dammouse. Workshop closed c1880. Second studio, opened subsequently in Rue Blomet, Paris, under direction of Chaplet, produced stoneware, slip painted in cloisonnist style reminiscent of painters Emile Bernard and Paul Gauguin; taken over by Chaplet in 1885. Production of Haviland & Co. at Limoges includes tablewares, some with decoration by leading designers.
Impressed marks used at Auteuil (i) and Rue Blomet (ii).

HOENTSCHEL, Georges (1855-1915)

Architect, sculptor and ceramist. Close friend and patron of J. *Carriès, worked in similar style. Bought Château Montriveau on Carriès's death.
Impressed monogram.

JEANNENEY, Paul (1861-1920)

Ceramist. Collector of Oriental ceramics; in 1890, joined artistic colony of potters led by J. *Carriès at St Amand-en-Puisaye (Nièvre), and made stoneware in style of Japanese folk pottery.
Collaborated on sculptural ceramics with

P.-F. *Fix-Masseau and cast in stoneware bronzes by Auguste Rodin.
Incised signature.

KELLER & GUÉRIN

(i) (ii)

Manufacturers at Lunéville (Meurthe-et-Moselle). Designs commissioned from sculptor, Ernest Bussière, and E. *Lachenal, among others.
Painted (i) and impressed (ii) marks.

LACHENAL, Edmond (1855-c. 1930)

LACHENAL

Ceramist. Began work with T. *Deck at age of 15. In 1880 established own studio at Malakoff, Paris; by 1887 had moved to Chatillon-sous-Bagneux. Style developed from painted faience to stoneware decorated with *flambé* glazes. Son, Raoul Lachenal, also made stoneware.
Painted mark.

LAURENT-DESROUSSEAUX, Henri Alphonse Louis (1865-1906)

Painter, illustrator. From 1898 collaborated with H. *Robalbhen on stoneware in Art Nouveau style.
Incised signature.

LEBOEUF, MILLIET & Co.

CREIL

L M & C℞

MONTEREAU

China manufacturers of Creil (Oise) and Montereau (Seine-et-Marne) united after working separately from 18th century and acquired (1841) by firm of Leboeuf and Milliet. Made table service (1867) designed by E. *Rousseau with decoration by Félix Bracquemond.
Printed mark.

LENOBLE, Emile (1875-1940)

Ceramist. Worked (1903-09) for father-in-law, E. *Chaplet, at Choisy-le-Roi (Seine). From c1907 influenced by glazes and decoration of Korean and Sung dynasty Chinese ceramics.
Impressed mark.

CERAMICS

LÉVY-DHURMER, Lucien (1865-1953)

(i)

(ii)

Painter. Designed shapes and decoration for C. *Massier (1887-95); artistic director of Massier workshop.
Impressed (i) and painted (ii) marks.

LION, Eugène (1867-1945)

Ceramist. One of family of potters at St Amand-en-Puisaye (Nièvre) made stoneware in Oriental manner, continuing style of father (once student of J. *Carriès). Incised signature.

MAISON MODERNE, LA

Retailers. Under management of art critic and historian Julius Meier Graef, commissioned designs from many leading designers, e.g. A. W. *Finch, M. *Dufrêne.
Printed mark.

MASSIER, Clément (1845-1917)

C.M
Golfe-Juan.
(A.M)

Ceramist. Learnt pottery at Vallauris kilns of father, Jérôme, who had started production of art pottery at nearby Golfe-Juan (Alpes-Maritimes) in 1872. Subsequently took direction of father's studio, becoming independent in 1883. Developed lustre glazes and employed as decorators various artists including L. *Lévy-Dhurmer.
Painted mark.

MASSIER, Delphin (fl first half 20th century)

D M
V.

Ceramist. Elder son of C. *Massier, made pottery at Vallauris (Alpes-Maritimes).
Painted initials.

MASSIER, Jérôme *fils*

JEROME
MASSIER
JPrs
Vallauris
(AM

Ceramist. Younger son of C. *Massier, took over workshops on father's death. Painted marks.

J.Massier fils

METTHEY, André (1871-1921)

Ceramist. Initially stonemason, established kiln after military service; exhibited stoneware in 1901. After *c*1906, produced tin-glazed earthenware decorated by artists of Paris school, e.g. M. de *Vlaminck. Exhibited at Salon d'Automne in 1909. Later, working alone, inspired by styles of Islamic pottery and Hispano-Moresque ware. Decoration includes geometrical or stylized plant designs and, afterwards, human or animal figures.
Incised signature and initials.

MILET, Optat (fl. late 19th century)

O.MILET
Sèvres

Modeller, decorator. Worked for *Sèvres factory (1862-79) and established own workshop at Sèvres (Hauts-de-Seine) *c*1876. Much work fired at kilns of C. *Massier.
Painted mark.

MOREAU-NÉLATON, Camille (1840-97)

C.— Moreau

Painter, ceramist. Born Camille Nélaton, met husband (painter and graphic artist, A. F. Moreau) at her uncle's studio, where she learnt to paint. First exhibited ceramics in 1867, and in same year began to work for T. *Deck. In 1873, adopted technique of *barbotine* decoration, working independently in Japanese style. Painted signature.

MOREAU-NÉLATON, Etienne
(1859-1927)

Painter, ceramist. Son of C. *Moreau-Nélaton, also employed Japanese style in decoration. Made ceramics from 1898 on own estate, La Tournelle, following technical traditions of his estate potter. Some work sold through *Primavera. Incised monogram.

MOUGIN, Joseph (1876-?1961)

Ceramist. With brother, Pierre, studied at Ecole des Beaux-Arts, Paris, returned to home town of Nancy (c1900) and started workshop; made ceramic figures and sculptural vases in stoneware after models by various sculptors including J. *Gruber. Painted or incised mark.

MUCHA, Alphons Maria (1860-1939)

MUCha

Painter, graphic artist, poster artist; designed transfer printed decoration for china. For biography see GRAPHICS. Printed signature.

NAUDOT, Camille, & Cie

Porcelain manufacturers in Paris. Work similar in style to products of *Sèvres factory. Specialised in *émaux à jour* decorative technique. Printed mark.

PACTON, Abbé Pierre (1856-1938)

Ceramist. Parish priest at Arquian, near St Amand-en-Puisaye (Nièvre). Started to make stoneware after seeing work of J. *Carriès. Worked with carpenter André Minil, incorporating initials AM in own incised monogram.

PARVILLÉ, Léon (d 1885)

Architect, ceramist. During work in 1863 on restoration of ancient Turkish buildings, began collection of Isnik pottery. Subsequently decorated pottery in Isnik styles, first exhibiting in early 1870s; some other work painted in Japanese manner. Wrote *Architecture et décoration turques en XVme siècle* (1874). Painted monogram.

PIERREFONDS

Ceramics factory founded in 1885 at Pierrefonds (Oise). Société Faïencière founded there (1904) under direction of Eugène Santerre. Vases with crystalline glazes manufactured until 1910. Printed mark.

PILLIVUYT, Charles & Co.

Faïence and porcelain manufacturers, founded at Mehun-sur-Yèvre (Cher) in 1854. Produced wares decorated with *pâte-sur-pâte*, or with high-fired glaze effects. Printed mark.

POINTU, Jean (1843-1925)

Ceramist. One of family of potters, worked at St Amand-en-Puisaye (Nièvre) in style of J. *Carriès. Incised rebus mark.

POINTU, Léon (1879-1942)

Ceramist. Worked with father J. *Pointu at St Amand-en-Puisaye. Incised signature.

PRIMAVERA

Retailers. Department of Paris store, Au Printemps, selling art pottery made by several artists, who usually incised work with retailer's name.

ROBALBHEN, Henri-Leon-Charles

ROBALBHEN

Ceramist. Exhibited at Salon des Artistes Français (1896). Worked with H. *Laurent-Desrousseaux from 1898. Incised signature.

ROUSSEAU, Eugène

MODÈLE

E ROUSSEAU

A

PARIS

Modeller. For *Leboeuf, Milliet & Co. modelled tableware which was decorated by Félix Bracquemond, 1867. Printed mark.

RUMÈBE, Fernand (1875-1952)

F.RUMÉBE

Ceramist. Brought up in Turkey, learnt to make pottery while working for about a year with E. *Decoeur. Work usually decorated with Middle Eastern designs from variety of sources. Painted mark.

SERRÉ, Georges (1889-1956)

Ceramist. Apprenticed at *Sèvres factory at age of 13. Taught ceramics in Indochina for five years after World War I. Established own studio on return to Paris. Worked in stoneware and produced some sculpture after models made by friends who were sculptors. Incised initials.

SÈVRES

National porcelain factory founded at Sèvres (Hauts-de-Seine) in 1756. *Pâte-sur-pâte* decoration developed by Marc-Louis Solon in mid-late 19th century. Factory, later under direction of T. *Deck, also employed such artists as A. *Dammouse and T. *Doat. Figures modelled by Auguste Rodin and A. *Léonard. Notable artists who worked for factory in 20th century include Maurice Gensoli and E. *Decoeur. Printed, impressed or relief moulded marks.

SIMMEN, Henri (1880-1963)

Hₛim

Ceramist. After training in architecture, turned to pottery and studied under E. *Lachenal. Established own studio for production of saltglaze stoneware. After World War I, travelled in Far East and, on return to France, made stoneware decorated in glazes of subtle colours. Painted mark.

THESMAR, André Fernand (1843-1912)

Artist-craftsman. Worked mainly in enamels on jewelry and metalwork; also decorated ceramics. Painted monogram.

VLAMINCK, Maurice de (1876-1958)

Painter. Among artists who decorated earthenware made by artist potter A. *Metthey. Painted signature.

BOCH FRÈRES

Manufacturers. Established (1841) in Hainault; acquired works e.g. at La Louvière and Tournai in Hainault, and Septfontaines in Luxembourg. Produced wide range of art pottery and domestic wares. 'Grès-Keramis' and 'Keramis' among brand names.
Printed or impressed marks.

CATTEAU, Charles (b 1880)

Ceramist. Studied at Ecole Nationale de Sèvres. 1904-06: worked for porcelain factory at *Nymphenburg, Bavaria. Between c1900 and 1925, decorated 'Keramis' ware made by *Boch Frères, painting landscapes, animals or geometrical patterns in slip.
Printed or impressed signature.

DE RUDDER, Isidore (1855-1943)

Sculptor and ceramist. Studied at Académie Royale des Beaux Arts, Brussels. Soon afterwards, had own kiln at pottery of Vermeren-Coché, Brussels, for whom (from 1900) modelled masks, tile panels in low relief, statuettes, etc.
Incised monogram.

FINCH, Alfred William (1854-1930)

Painter, graphic artist and ceramist. For biography see SCANDINAVIAN CERAMICS.
Incised mark on pottery produced at Forges, Belgium.

GUÉRIN, Roger (fl early
20th century)

Ceramist. Produced wide range of salt-glazed art pottery and domestic ware in own workshops; fired stoneware sculpture made by M. *Wolfers. Member of Societé des Grès d'Art de Bouffioulx. Incised marks.

WOLFERS, Marcel (fl c1920)

Sculptor, jeweller, ceramist. Worked in workshops of father, P. *Wolfers. Sculptures in crackle-glazed white faience fired by Vermeren-Coché and in stone-ware by R. *Guerin.
Incised or painted signatures.

WOLFERS, Philippe (1858-1929)

Sculptor, metalworker, jeweller, designer. For biography see METALWORK & JEWELRY. Studied under I. *De Rudder. Work includes some bronze vases cast (1897) in stoneware by firm of E. Muller of Ivry (Seine).
Incised signature.

DUTCH CERAMICS

AMPHORA

Ceramics factory at Oegstgeest-lez-Leiden, under management of C. Perelaer and Van Sillevolt. Early 20th century production includes underglaze painted china after designs by C. *van der Hoef. Painted mark.

AMSTELHOEK

AMSTERDAM
·HOLLAND·

Workshops producing ceramics, metalwork and furniture, founded at Omwal in 1894-95 by W. Hoeker; under management of C. J. *van der Hoef, also supervisor of designs. Ceramics workshops merged with *Haga in 1907 and De *Distel in 1910.
Printed marks.

BERLAGE, Hendricus Petrus (1856-1934)

Architect, designer. Studied under architect Gottfried Semper in Dresden. Designed furniture, ceramics manufactured by *Holland, and metalwork for retail studio, 't Binnenhuis.
Painted mark.

BRANTJES, W. N.

Ceramist. Worked for *Haga and subsequently established own pottery. Painted mark.

BROUWER, William Coenrad (1877-1933)

(i) (ii)

(iii)

Ceramist, interior designer and artist craftsman. Born in Leyden; studied there at drawing school of W. J. Lampe. Worked (1898-1901) for Gredewaag factory, makers of clay pipes, in Gouda. In 1898 established own pottery at Gouda and, in 1901, moved to Leiderdorp. Incised (i, ii) and impressed (iii) marks.

COLENBRANDER, Theodor A. C.

(i) (ii)

(iii)

Ceramist, textile designer. Worked in office of architect at Arnhem, Gelderland, spent one year in Paris; subsequently director of *Rozenburg factory (1885-89). Later director of carpet factory; also worked for *Zuid-Holland and *Ram potteries.
Painted (i, ii) and printed (iii) marks.

DISTEL, DE

Ceramics factory founded (1895) at Amsterdam by J. M. Lob. Produced painted earthenware and, in 1910, absorbed *Amstelhoek factory. Designers include L. *Nienhuis.
Printed mark.

GOUDA

See ZUID-HOLLAND.

HAGA

Manufacturers. Pottery at Purmerend, used as cement works from 1894, taken over (1897) by E. Estié & Co. of *Zuid-Holland, and re-converted to art pottery under W. *Brantjes. C. *Lanooy artistic director (1906-07). Pottery amalgamated with *Amstelhoek in 1907.
Painted and printed marks.

HOLLAND

Ceramics factory founded at Utrecht in 1856; re-organized by J. W. Mijnlieff (1896). 1904-06: manufactured utensils, tableware and tiles from designs by H. *Berlage and J. P. van den Bosch, commissioned by 't Binnenhuis.
Painted marks.

LANOOY, Christian J. (1881-1947)

Ceramist, glass artist. Worked for
*Haga factory, as artistic director
(1906-07). Subsequently worked for
*Zuid-Holland factory until 1920. Also
worked independently.
Painted marks.

LE COMTE, Adolphe (1850-1921)

Ceramist. Artistic director of De
*Porceleyne Fles (1877-1919).
Incised signature.

LION CACHET, C. A. (1864-1945)

Designer, craftsman. Worked for De
*Distel c1900.
Painted mark.

MENDES DA COSTA, Josef (1863-1939)

Sculptor and ceramist. Son of stone-
mason; after working with sculptor Zijl,
started (c1898) to make objects and
statuettes in stoneware. In 1900 worked
for 't Binnenhuis. Collaborated with H.
*Berlage and other architects.
Incised mark.

MULLER, L. T.

Ceramist. Worked as designer and
decorator for *Zuid-Holland in early
20th century.
Painted mark.

NIENHUIS, Lambertus (1873-1960)

Ceramist. Trained as house painter,
subsequently attended art schools at
Groningen and Amsterdam. Worked as
designer for De *Distel (1895-1911).
Taught ceramics (1912-17) at Kunstge-
werbeschule founded by Karl Ernst
Osthaus at Hagen, Germany. On return to
Holland, continued teaching and started
to make ceramics independently.
Painted mark.

NIEUWENHUIS, Theodor Willen
(1866-1951)

Designer, graphic artist. Studied in
Amsterdam under architect, P. J. H.
Cuypers. Travelled to Berlin, Dresden,
Prague, Vienna, Paris (1889-90). Designer
for De *Distel from 1895.
Painted mark.

NOORDWIJK

Ceramic factory. Produced faience in
style similar to that of *Zuid-Holland.
Painted mark.

PADDENSTOELEN, DE (VIER)

Ceramists. Group of potters formed
(1920) at Utrecht: K. Mertens, J. C. van
Ham, E. Snel and C. J. van Muyen.
Made artistic and domestic pottery.
Printed mark.

PORCELEYNE FLES, DE

Manufacturers. Pottery producing Delft
in 17th century, used from 1876 by Joost
Thooft for production of underglaze
painted earthenware, often in traditional
styles. Firm traded as Thooft &
Labouchère from 1890; obtained Royal
Privilege (1919) to use title Koninklijke
Delftsch-Aardewek Fabriek 'De
Porceleyne Fles'. A. *Le Comte art
director (1877-1919).
Painted mark.

RAM

„RAM"

Manufacturers. Pottery founded at
Arnhem in 1923 by H. van Lerven.
Decorative designs supplied by T.
*Colenbrander.
Painted mark.

ROZENBURG

(i)

(ii)

(iii)

Manufacturers. Established in 1885 at the Hague by W. W. freiherr von Gudenberg, son of German ceramist. T. *Colenbrander (1885-89) and J. Juriaan Kok (1894-1913) among artistic directors. Firm produced painted earthenware using, by 1890, semi-porcellaneous body, cast very thinly and known as 'eggshell'. Comparatively coarse body subsequently used, and fluid, irregular shapes of earlier work gave way to more conventional forms. Decorative designs usually influenced by Javanese batik. Production ceased in 1914; later attempt (1919) to revive ware under name 'Neuw Rozenburg' lasted only four years. Painted marks: 1885-90 (i), c1890 (ii), c1890-1914 (iii).

ST LUKAS

ST.LuKAS UTRECHT

Manufacturers of decorative earthenware in Utrecht.
Painted mark.

VAN DER HOEF, Christian Johannes (1875-1933)

Sculptor, medallist and graphic artist. Supplied designs for *Amstelhoek (1894-1910); also for *Zuid-Holland and *Amphora factories.
Painted signature.

ZUID-HOLLAND

Ceramics factory, Zuid-hollandsche Plateelbakkerij, founded at Gouda in 1897 by E. Estié & Co. Specialized in earthenware decorated with underglaze painting of Javanese inspiration. Artists include C. J. *Lanooy, C. J. *van der Hoef, T. *Colenbrander and L. *Muller. Painted marks.

BAUSCHER BROS

Manufacturers of porcelain at Weiden (Oberpfalz). Produced table services designed by P. *Behrens, c1900. Printed marks.

BEHRENS, Peter (1868-1940)

Painter, architect, designer and graphic artist. For biography see METALWORK & JEWELRY. Supplied designs for *Bauscher Bros and Reinhold *Hanke. Monogram.

BERLIN, STAATLICHE (or KÖNIGLICHE) PORZELLAN-MANUFAKTUR

Porcelain manufacturers. Founded in 1763. Research laboratory set up in 1878 under H. *Seger and Albert Heinecke achieved Oriental high-fired glaze effects. Porcelain normally decorated with under-glaze painting; T. *Schmuz-Baudiss employed from 1902, art director from 1908. Wide range of figures produced. Printed marks.

BUNZLAU, KÖNIGLICHE KERAMISCHE FACHSCHULE

K.K.F.S.

Bunzlau.

Technical school at Bunzlau (in area of Silesia noted for production of saltglaze in 18th and 19th centuries) producing *flambé* glazed stoneware c1900. Incised mark.

BURGAU, PORZELLANMANUFAKTUR

Porcelain factory of Ferdinand Selle at Burgau-bei-Göschwitz. Some early 20th century tableware produced to designs by A. Müller. Printed mark.

BÜRGELER KUNSTKERAMISCHE WERKSTÄTTEN

Ceramics workshop founded c1900 by Carl Fischer at Bürgel, near Jena. Mainly produced ornamental ware. Printed mark.

CERAMICS

CADINEN, KONIGLICHE
MAJOLIKA-WERKSTATTE

Ceramics factory, privately owned by
Kaiser Wilhelm II (1859-1941).
Impressed mark.

CHRISTIANSEN, Hans (1866-1945)

Painter, graphic artist, designer. Studied
at Kunstgewerbeschule in Munich.
Travelled in Italy (1889) and America
(1893). In 1895 studied at Académie
Julian in Paris. Joined artists' colony at
Matildenhöhe, Darmstadt (1899);
returned to Paris in 1902. Designed
ceramics manufactured by *Krautheim &
Adelberg.
Painted mark.

DARMSTADT, GROSSHERZOG-
LICHE KERAMISCHE
MANUFAKTUR

Ceramics manufacturers. Founded by
Grand Duke Ernst Ludwig of Hesse.
Under control of J. *Scharvogel, 1906-13.
Produced figures and vases after designs
by artists associated with Matildenhöhe
artists' colony at Darmstadt.
Impressed marks.

DARMSTADT, VEREINTE
KUNSTGEWERBLER

Group of designers, probably members of
artists' colony at Matildenhöhe,
Darmstadt. *c*1900-*c*1910: supplied designs
for porcelain tableware to P. *Rosenthal
& Co.
Printed mark.

FESTERSEN, Friedrich

Festersen

Ceramist. Made faience in Berlin
*c*1905-10.
Impressed mark.

FRAUREUTH, PORZELLANFABRIK

Porcelain factory at Fraureuth, producing
wide range of useful and decorative wares
in 1920s and 1930s.
Printed mark.

GERZ, Simon Peter, I

Stoneware manufacture at Hohr, Westerwald. In early 20th century produced jugs to designs by P. *Wynand, etc.
Impressed mark.

HANKE, REINHOLD

Factory at Hohr, Westerwald, producing stoneware decorated with *flambé* glazes, sometimes designed by H. *van de Velde and P. *Behrens, in early 20th century.
Incised mark.

HEUBACH, GEBRUDER

Porcelain factory founded (1822) at Lichte, near Wallendorf, Thuringia. Specialized in figures after models by sculptors, e.g. P. *Zeiller, Christian Metzger, Wilhelm Neuhauser, H. Krebs.
Printed marks.

KANDERN, TONWERKE

(i)

(ii)

Ceramic manufacturers at Kandern, Baden. M. *Laüger artistic director 1895-1913. Production includes figures after models by sculptor, B. *Hoetger.
Impressed mark, incorporating Laüger's monogram (i) and incised monogram marks (ii).

KARLSRUHE, STAATLICHE
(or GROSSHERZOGLICHE)
MAJOLIKA-MANUFAKTUR

Manufacturers. Founded in 1900 by H. *Thoma and Wilhelm Süs; moved (1916) to Hardtwald. Production primarily figures modelled by sculptors, e.g. J. *Wackerle, Franz Blazek, Emil Pottner. Also manufactured vases designed by M. *Laüger.
Impressed or printed marks.

KORNHAS, Carl (1857-1931)

Sculptor and ceramist. Studied at Kunstgewerbeschule Nuremburg; travelled in Italy, learning technique of Italian *maiolica*. On return to Germany, produced pottery manufactured by *Karlsruhe factory in style of 15th century *maiolica* and experimented with crystalline glazes at Weingarten porcelain factory.
Impressed marks.

KRAUTHEIM & ADELBERG

Porcelain manufacturers of Selb, Bavaria. Produced tableware designed by H. *Christiansen.
Printed mark.

LANDSHUT, STAATLICHE (or KÖNIGLICHE) KERAMISCHE FACHSCHULE

Technical school at Landshut, Bavaria. Founded in 1873. Produced china figures from *c*1910.
Impressed mark.

LAÜGER, Max (1864-1952)

Painter, graphic artist, ceramist. Studied painting and interior decoration (1881-84) at Karlsruhe Kunstgewerbeschule; subsequently taught there. Also studied (1882-83) at Académie Julian, Paris. 1895-1913: artistic director of Tonwerke *Kandern. Took control of workshops at Grossherzogliche Majolika-Manufaktur, *Karlsruhe, 1916. Specialized in slip decorated wares.
Incised monogram.

MAGNUSSEN, Walter (b 1869)

Modeller, ceramist. Working in Munich (*c*1900), modelled shapes made in stoneware by J. *Scharvogel. Subsequently taught at art school in Bremen.
Impressed monogram.

MANZEL, Ludwig (1858-1936)

Sculptor. Worked in Berlin from 1889. Designed low-relief plaques for *Cadinen factory.
Incised initials.

MARGOLD, Emanuel Josef (b 1889)

Graphic artist and designer. Studied at Academy in home town, Vienna; worked in Darmstadt; settled (1929) in Berlin. Designed ceramics, including containers for biscuit manufacturers, H. Bahlsen, in Hanover.
Printed mark.

MEHLEM, FRANZ ANTON

Manufacturers (from 1836) of useful and ornamental ceramics at Bonn. Products marketed under name 'Royal Bonn'.
Printed marks.

MEISSEN, STAATLICHE
(or KÖNIGLICHE)
PORZELLANMANUFAKTUR

Porcelain manufacturers founded in 1710. Under management of Horst Carl Brunnemann (1895-1901), achieved crystalline and other glaze effects. Commissioned designs for tableware from leading artists, e.g. H. *van de Velde, R. *Riemerschmid and Adelbert Neimeyer, and made figures after models by P. *Scheurich and other sculptors. Max A. Pfeiffer director from 1918. Also produced porcelain painted under glaze in blue, in style of *Copenhagen factory.
Painted mark.

MERKELBACH, REINHOLD

Stoneware manufacturers at Grenzhausen, near Coblenz. In early 20th century produced jugs and bowls to designs by R. *Riemerschmid, P. *Wynand, A. *Müller, Charlotte Krause etc., and figures after models by H. *Wewerka.
Impressed marks.

**MERKELBACH & WICKE,
VEREINIGTE FABRIKEN**

Amalgamation of some stoneware
factories in area of Grenzhausen,
Westerwald. Successors to firm of
Reinhold *Merkelbach.
Impressed marks.

METZLER BROS & ORTLOFF

Porcelain factory founded at Ilmenau
(Thuringia) in 1875.
Impressed marks.

MÜLLER, Albin (1871-1941)

Nach Entwurf
von
PROF.A.MÜLLER
ARCHITEKT
Darmstadt

Architect, designer. For biography see
METALWORK & JEWELRY. Designed
tableware manufactured by *Burgau
porcelain factory and E. *Wahliss.
Printed mark.

MUTZ, Hermann (1845-1913)

Ceramist. Worked as apprentice in
Berlin, took over father's pottery in
Altona; joined in firm by son R. *Mutz.
Imitated matt and semi-matt glazes of
Japanese stoneware. Worked with
sculptor, Ernst Barlach, from 1902.
Impressed and incised marks.

MUTZ, Richard (1872-1931)

Ceramist. Son of H. *Mutz; after
working with father established own
pottery (1904) in Berlin Wilmersdorf.
Pottery closed in 1929.
Impressed mark.

**NYMPHENBURG, STAATLICHE
(or KÖNIGLICHE)
BAYERISCHE PORZELLAN-
MANUFAKTUR**

Porcelain manufacturers. Founded in
1747 and leased from 1887 to Albert
Bäuml, who was succeeded on death by
three sons. Produced tableware; also
figures modelled by sculptors e.g. J.
*Wackerle, Franz Blazek, Theodor
Kärner and P. *Scheurich.
Printed mark.

OBERLAUSITZER KERAMISCHE WERKSTÄTTEN

Ceramic workshops founded at Niederbeilau, Silesia in 1920s, under supervision of Paul Jurgel. Impressed mark.

OHME, H.

Manufacturers of porcelain tableware at Niedersalzbrunn, Silesia. Printed mark.

ROSENTHAL, PHILIPP & CO.

Porcelain manufacturers, founded at Selb, Bavaria, in 1874. Production included tableware (e.g. 'Canova' and 'Donatello' ranges), vases and figures; Walter Gropius among artists and designers commissioned to supply designs. Printed marks.

ROYAL BONN

See MEHLEM.

SÄCHSISCHE PORZELLANFABRIK

Porcelain factory established in early 1870s by Carl Thieme at Potschappel-Freital, near Dresden. Painted mark.

SCHARVOGEL, Johann Julius (1854-1938)

Ceramist. Worked for *Villeroy & Boch at Mettlach, before establishing own workshop (c1900) at Munich. Director of Grossherzogliche Keramische Manufaktur at *Darmstadt from 1906. Impressed mark.

SCHMIDT-PECHT, Elisabeth

Decorative artist. Designed and decorated art pottery made by brother, J. A. Pecht, at Constance during first quarter of 20th century. Usually employed *sgraffito* technique.
Incised marks.

SCHMUZ-BAUDISS, Theo (1859-1942)

Painter, graphic artist, ceramist. Learned technique of pottery in 1896 and, later, porcelain. Some early work made in collaboration with J. *Scharvogel. Employed at *Berlin porcelain factory from 1902; artistic director, 1908-26. Noted for underglaze painted decoration. Painted signature, printed monograms.

SCHWARZBURGER WERKSTÄTTEN FÜR PORZELLANKUNST

Porcelain factory. Founded (1908) at Unterweissburg, Schwarzburg-Rudolstadt, by Max Adolf Pfeiffer. Later amalgamated with Volkstedter Porzellanfabrik. Specialized in production of figures after models by e.g. Ernst Barlach, Gerhardt Marcks, P. *Scheurich.
Impressed mark.

SEGER, Hermann (1839-93)

Ceramist. Studied at Rostock (gained doctorate in philosophy, 1868). From 1878 in charge of new chemical research laboratories at *Berlin porcelain factory. Experiments led to development of *sang de boeuf* and celadon glaze effects; also evolved 'Seger cones' used for determining kiln temperatures.
Painted mark.

SEIDLER, Hermann

Ceramist. Made art pottery; worked
independently at Constance c1900.
Incised mark and signature.

SWAINE & CO.

Porcelain manufacturers at Hütten-
Steinach. Produced tableware.
Printed mark.

THOMA, Hans (1839-1925)

(i) (ii)

Painter, graphic artist, designer. For
biography see GRAPHICS. Co-founder
of Majolika Manufaktur at *Karlsruhe
(1900). Painted faience, often with
dragons, nymphs etc.
Painted (i) and incised (ii) marks.

THOMAS & ENS

Porcelain factory established (1903) at
Marketredwitz, Bavaria, making orna-
mental wares. Taken over by P.
*Rosenthal & Co. in 1908.
Printed mark.

VAN DE VELDE, Henry Clemens
(1863-1957)

Architect, artist-craftsman, designer. For
biography see FURNITURE &
TEXTILES. Designed decoration and/or
shapes for *Meissen factory, Reinhold
*Hanke and *Bürgeler Kunstkeramische
Werkstätten.
Impressed monogram.

VELTEN-VORDAMM

Factory producing ornamental china and
tableware briefly in early 20th century,
under management of Mark
Brandenburg.
Impressed mark.

CERAMICS

VEREINIGTE WERKSTÄTTEN FÜR
KUNST IM HANDWERK

Workshops established (1897) in Munich by, among others, P. *Behrens, R. *Riemerschmid, T. *Schmuz-Baudiss. Produced ceramics as well as furniture, metalwork, etc.
Printed mark.

VIERTHALER, Ludwig (1875-1967)

L·VIERTHALER

Sculptor, ceramist, designer. Taught at Hanover Fachschule from 1921. Modelled figures for reproduction in porcelain at *Meissen factory.
Moulded signature.

VILLEROY & BOCH

Manufacturers; separate companies combined in early-mid 19th century, produced wide range of utilitarian and ornamental wares in several European factories, notably at Vaudrevanges (Wallerfangen) in Saar basin, Septfontaines (Luxembourg), Dresden, Schramberg; production of artistic stoneware centred at Mettlach in Rhineland (where artists included J. *Scharvogel).
Impressed marks.

VON HEIDER, Max

Ceramist. With sons Hans, Fritz and Rudolf, already established artists, started studio at Schongau-am-Lech, Bavaria. Produced lustreware c1900.
Impressed mark.

WACHSTERSBACHER
STEINGUTFABRIK

(i) (ii)

Founded (1832) at Schierbach, Hesse-Nassau. Studio (Kunstabteilung) opened in early 20th century under direction of Christian Neureuther produced vases, plaques and figures. Modellers included Ernst Riegl.
Impressed mark of factory (i), printed mark of Neureuther's studio (ii) and special printed mark on figures (modelled by Riegl) presented by Grand Duke and Duchess of Hesse-Darmstadt.

WACKERLE, Josef (b 1880)

WACKERLE.

Sculptor, modeller. Studied in Partenkirchen and Munich. Artistic director at *Nymphenburg factory, 1906-09. Taught in Berlin (1909-17) and Munich (from 1917). Modelled figures for reproduction in porcelain by Nymphenburg and *Berlin factories. Incised signature.

WEWERKA, Hans (1888-1917)

H.WEWERKA.

Sculptor, modeller. Made figures for production in stoneware by Reinhold *Merkelbach. Impressed mark.

WYNAND, Paul (1879-1956)

PAUL WYNAND

Sculptor, designer. Studied in Berlin and under Auguste Rodin in Paris. From 1905, taught at Imperial Ceramics School in Hohr. Taught in Berlin, 1934-55. Designed shapes for production in stoneware by Reinhold *Merkelbach. Impressed mark.

ZEILLER, Paul (1880-1915)

Paul Zeiller.

Sculptor. Studied at Munich academy. Worked in Berlin. Modelled animal figures for reproduction in porcelain by Gebruder *Heubach and *Metzler Bros & Ortloff. Incised signature.

AUSTRIAN CERAMICS

AMPHORA

See RIESSNER, STELLMACHER & KELLNER.

AUGARTEN

Porcelain manufacturers. Vienna Porcelain Factory (founded 1718) began production at converted Schloss Augarten in 1923. Products include tableware and figures after designs by artists e.g. J. *Hoffmann, M. *Powolny, O. *Prutscher.
Impressed or printed marks.

'AUSTRIA' KUNSTGEWERKLICHE WERKSTÄTTE

Workshop in Vienna; produced craft-work, including ornamental earthenware, c1920.
Printed mark.

BARWIG, Franz (1868-1931)

Modeller. Studied wood carving at Vienna Kunstgewerbeschule. Worked independently as sculptor, 1890-1904. Modelled animal groups independently and for *Augarten factory and *Wienerberger Werkstättenschule für Keramik.
Incised marks.

BAUDISCHE-WITTKE, Gudrun (b 1907)

Ceramist. Worked (1926-30) in ceramic design studio of *Wiener Werkstätte under J. *Hoffmann. Shared own ceramic studio with M. von Potoni (1930-36). Worked in Berlin, 1936-42; established own pottery at Hallstadt in 1943.
Incised and printed marks.

BAUER, Leopold (1872-1938)

Designer. Pupil of Otto Wagner; worked with J. *Olbrich and J. *Hoffmann in Vienna. Designed glass for *Loetz factory, ceramics, etc.
Impressed and incised marks.

BÖCK, JOSEF

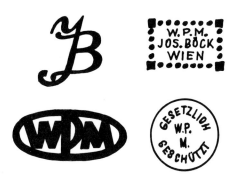

Firm of porcelain manufacturers. After succeeding father as owner of factory in Vienna (1887), Josef Böck built porcelain decorating studios in 1893. Commissioned designs for tableware from K. *Moser and J. *Sika in 1898, when firm became known as Wiener Porzellan-Manufaktur Jos. Böck.
Impressed or printed marks.

BUCHER, Hertha (b 1898)

Modeller. Studied at Vienna Kunstgewerbeschule under M. *Powolny. Worked for *Goldscheider and, in 1920, established own pottery.
Incised mark.

CALM-WIERINK, Lotte (b 1897)

Modeller. Studied at Vienna Kunstgewerbeschule under M. *Powolny. Worked with *Wiener Werkstätte, 1918-25.
Incised mark.

'CANDIA'

Firm established (1921) in Vienna for manufacture and sale of ceramics and other goods; closed in 1939.
Impressed mark.

DUXER PORZELLANMANUFAKTUR

Porcelain manufacturers established at Dux, Bohemia, by E. Eichler in 1860. Produced wide range of ornamental wares under name of 'Royal Dux'.
Raised mark.

EMMEL, Bruno (b 1877)

Ceramist, designer. Studied under J. *Hoffmann at Vienna Kunstgewerbeschule, and designed some ceramics made there. Designs also executed at *Wiener Kunstkeramische Werkstätte. Taught at Znaim Fachschule.
Painted mark.

FLÖGL, Mathilde

Artist-craftswoman. Studied under J. *Hoffmann at Vienna Kunstgewerbeschule. Worked (1916-31) in ceramics, glass-painting, posters and leatherwork with *Wiener Werkstätte. Had own studio in Vienna (1931-35).
Incised marks.

FORSTER, A. & Co.

Art pottery established (1899) in Vienna. Specialized in figures, clock cases, lampstands, etc., made in porcelain, stoneware and faience. On liquidation in 1908, taken over by *Wiener Kunstkeramische Werkstätte.
Printed mark.

FORSTNER, Leopold (b 1878)

Artist in mosaics. Studied at Vienna, Munich, and in Italy. In 1908, established Wiener Mosaikwerkstätte; mosaics made with ceramics, glass, marble, etc.
Painted mark.

GEMIGNIANI, Valmore (b 1879)

Painter, sculptor. Modelled figures for reproduction in porcelain by F. *Goldscheider.
Printed signature.

GMUNDNER KERAMIK

Art pottery founded (1909) at Gmunden by F. and E. *Schleiss. In 1912, amalgamated with *Wiener Keramik, became Vereinigte Wiener und Gmundner Keramik.
Painted and impressed marks.

GOLDSCHEIDER

(i)

(ii)

(iii)

(iv)

(v) (vi)

Manufacturers of faience and porcelain operating 1885-1953 in Vienna, started by Friedrich Goldscheider (1845-97). Early production includes terracotta busts, mainly of Middle Eastern inspiration. Succeeding husband in 1897, Regina Lewit-Goldscheider ran firm until 1918 with brother-in-law Alois Goldscheider. Production of figures continued; sculptural vases made under influence of Art Nouveau. From 1920 under control of founder's sons, Walter and Marcell, firm adopted style prevailing in Vienna in 1920s. In 1927, Marcell Goldscheider left to establish Vereinigte Ateliers für Kunst und Keramik.
Printed or impressed marks: (i, ii, iii) Friedrich Goldscheider; (iv, v) Walter and Marcell Goldscheider; (vi) Marcell Goldscheider.

HANAK, Anton (1875-1934)

Sculptor, modeller. Student at Vienna Academy. Member of Vienna Secession (1906-10). Modelled ceramic ovens decorated with figures from 1915. Painted mark.

CERAMICS

HOFFMANN, Josef (1870-1956)

Designer. For biography see METAL-WORK & JEWELRY. Designed ceramics for *Augarten factory and *Wiener Werkstätte.
Painted and impressed marks.

ISKRA, Franz Zaver (b 1897)

Ceramist. Learnt pottery in family firm at Ober-Döbling, near Vienna. Mainly made figures. In 1928 invented red glaze, registered as 'Iskarot'.
Started pottery school in 1930.
Impressed mark.

KARAU, WERKSTÄTTE

Workshop producing ceramics and other crafts. Founded (1919) by Georg Karau in Vienna; closed in 1925.
Impressed mark.

KERAMISCHE WERKGENOSSENSCHAFT

Art pottery founded (1911) in Vienna by Helena Johnova, Rosa Neuwirth and Ida Schwetz-Lehmann, pupils of M. *Powolny at Vienna Kunstgewerbeschule. After liquidation of pottery (1920), principals worked independently.
Impressed mark.

KIRSCH, Hugo F. (1873-1961)

Ceramist. Studied at Munich and Vienna Kunstgewerbeschule. In 1906, established own ceramic workshop; using porcelain and stoneware, made figures, vases and architectural ceramics, some from own designs.
Incised or painted marks.

KLABLENA, Edward (1881-1933)

Ceramist. Studied at Vienna Kunst-gewerbeschule and in Germany. Modeller for *Berlin Porcelain factory (1909-10), before setting up own workshop at Langenzersdorf in 1911; continued to specialize in figures.
Painted marks.

KOPRIVA, Ena

Ceramist. Born and worked in Vienna. Studied at Vienna Kunstgewerbeschule, 1914-19. Worked at *Wiener Werkstätte. Assistant to J. *Hoffmann, 1928-37. Modeller of figures.
Painted mark.

LÖFFLER, Berthold (1874-1960)

Painter, designer, modeller. Studied at Vienna Kunstgewerbeschule. Taught in Vienna at school of art needlework (1905-09) and at Kunstgewerbeschule (1909-35). Co-founder of *Wiener Keramik in 1905 with M. *Powolny. Modelled figures, vases; painted pottery.
Painted marks.

MOSER, Kolo (1868-1918)

Designer, decorative artist. Studied painting in Vienna at Academy and Kunstgewerbeschule, where subsequently taught decorative painting. Co-founder of *Wiener Werkstätte; member of Vienna Secession. Designed ceramics for execution at Kunstgewerbeschule (where he taught from 1899) and by firm of J. *Böck.
Incised or painted marks.

OBSIEGER, Robert (1884-1958)

R·OBSIEGER

Ceramist. Studied at Vienna Kunst-gewerbeschule (1909-14) under B. *Löffler and M. *Powolny. Worked for industrial potteries and *Wiener Kunstkeramische Werkstätte. Taught at Kunstgewerbeschule and *Wienerberger Werkstättenschule für Keramik. Made figures, vases, ovens, etc. using wide range of decorative techniques.
Incised mark.

PECHE, Dagobert (1887-1923)

Designer, decorative artist. Studied in Vienna (1906-10) at Akademie der bildenden Künste. Designed decoration for porcelain manufactured by J. *Böck, made models for Vereinigte *Wiener und *Gmundner Keramik and *Wiener Werkstätte. Among leading workers of Wiener Werkstätte from 1915 until death; ran branch in Zurich (1917-18). Also designed glass, metalwork etc.
Incised or painted marks.

POWOLNY, Michael (1871-1954)

Ceramist. Studied (1894-1901) and later started ceramic department at Vienna Kunstgewerbeschule (succeeded as teacher by R. *Obsieger). Founder-member of Vienna Secession, 1897. Worked independently as sculptor, 1900-03. In 1905, co-founder with B. *Löffler of *Wiener Keramik. Also modelled for *Wieneberger Werkstättenschule für Keramik; specialized in figures.
Painted or impressed marks.

RIESSNER, STELLMACHER & KESSEL

Manufacturers established (1892) at Turn-Teplitz, Bohemia. Produced 'Amphora' porcelain during early 20th century.
Impressed marks.

RIX, Felicie (b 1893)

F.R.

Ceramist. Worked for *Wiener Werkstätte, 1917-30. Settled in Japan. Painted initials.

ROYAL DUX

See DUXER PORZELLAN-MANUFAKTUR.

SCHLEICH, Wilhelm (b 1881)

Sculptor, ceramist. Studied and later taught (1930-34) at Vienna Kunstgewerbeschule. Workshop foreman at *Wiener Keramik. Taught in, and ran, ceramics studio at Budapest Kunstgewerbeschule, 1911-14. Modeller for one year at *Meissen factory.
Painted marks.

SCHLEISS, Emilie

Decorative artist; married to F. *Schleiss. Studied at Vienna Kunstgewerbeschule, 1904-08.
Painted mark.

SCHLEISS, Franz (b 1884)

Ceramist. Studied at Vienna Kunstgewerbeschule, 1905-09. Founded *Gmundner Keramik, 1909, and established own pottery school in 1917. Designed ceramics for several industrial manufacturers.
Painted mark.

SIKA, Jutta (1877-1964)

Designer. Studied at Vienna Kunstgewerbeschule. Designed tableware for firm of J. *Böck.
Painted mark.

SINGER (-SCHINNERL), Susi (b 1895)

S.S.

Ceramist. Studied at Kunstschule für Frauen und Mädchen, 1909-15. Worked for *Wiener Werkstätte. Established own studio at Grünbach am Schneeberg, 1925.
Painted mark.

TEPLITZ FACHSCHULE

Technical college founded (1897) at Teplitz, Bohemia. High-temperature and lustre glaze effects developed c1900. Animal figures produced after models by A. *Gaul.
Impressed mark.

VIENNA KUNSTGEWERBESCHULE

Art school founded 1867, producing ceramics from *c*1900. First ceramics course under direction of Friedrich Linke. M. *Powolny instructor from 1909. Impressed marks.

WAHLISS, Ernst (1836-1900)

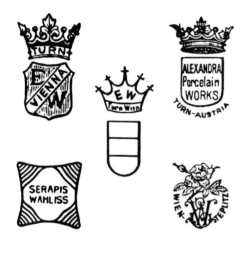

Retailer and manufacturer. Opened shop in Vienna (1863) with branches in London (1888) and Berlin (1896); agents for *Riessner, Stellmacher & Kessel and *Zsolnay. Began production of porcelain, *c*1900. Firm renamed 'Alexander Porcelain Works Ernst Wahliss' in 1905. Painted earthenware marketed as 'Serapis Fayence' introduced 1911. Printed marks.

WIENERBERGER WERKSTÄTTEN-SCHULE FÜR KERAMIK

Workshop school built 1919-21. Run by R. *Obsieger, 1921-32. Impressed mark.

WIENER KERAMIK

Ceramic studio. Founded in 1905 by B. *Löffler and M. *Powolny. Work included decoration of Palais Stoclet, Brussels. Amalgamated (1912) with *Gmundner Keramik to become Vereinigte Wiener und Gmundner Keramik. Designers include J. *Hoffmann, D. *Peche and Powolny; figures modelled by Löffler and Powolny. Impressed marks.

WIENER KUNSTKERAMISCHE WERKSTÄTTE

Art pottery started (1908) when Heinrich Ludescher and Robert Busch bought out employers, A. *Forster & Co. of Vienna. Ludescher left, 1909. Production includes figures and sculptured vases.
Printed and impressed marks.

WIENER WERKSTÄTTE

Craft workshops founded (1903) by K. *Moser, J. *Hoffmann and F. Wärndorfer. Until establishment of ceramic workshop (1913), and subsequently, artists worked in close association with *Wiener Keramik and Vereinigten *Wiener und *Gmundner Keramik. Workshops closed, 1932.
Impressed or incised marks.

WIESELTHIER, Vally (1895-1945)

Ceramist. Studied at Vienna Kunstgewerbeschule, 1914-20. From 1917, worked with *Wiener Werkstätte. Emigrated to USA in 1929.
Painted mark.

WIMMER, Eduard Josef (1882-1961)

Designer and modeller. Studied at Vienna Kunstgewerbeschule, 1901-07. Afterwards, among leading artists at *Wiener Werkstätte until workshop's closure in 1932.
Impressed marks.

ZSOLNAY

Ceramics factory at Pécs, Funfkirchen, Hungary. Vilmos Zsolnay (1828-1900) took over brother's factory (1865) and started production of art pottery. With chemist, Vinsce Wartha, in 1892 developed ruby-red lustre glaze, 'Eosin'. Zsolnay's son Miklos became manager of firm, 1899. Artists who designed decoration include Josef Rippl-Ronai and Laszlo Mattyasovsky. Firm's representative in Vienna was E. *Wahliss.
Printed marks.

ITALIAN CERAMICS

ARTE DELLA CERAMICA

Ceramic workshop operating in Florence, 1896-1906. Mainly produced porcelain with floral or animal designs painted in lustre. Flower-painter and designer, Galileo Chini (1873-1956), was artistic director until 1904, and brother, Chino Chini, technical director, 1901-06; workshop became Chini & Co. in 1906. Painted mark.

RICHARD-GINORI, SOCIETÀ CERAMICA

Manufacturers of ceramics at Doccia near Florence. Produced painted and lustre wares, some to designs by Gio Ponti. Printed marks.

ALUMINIA

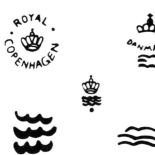

Faience factory established (1863) in Copenhagen. In 1882, acquired Royal *Copenhagen factory. Produced wide range of decorative china.
Painted mark.

COPENHAGEN

Danish Royal porcelain factory. Founded early 1770s, received royal privilege 1775. In 1882 merged with *Aluminia faience factory; taken over by Philippe Schou (1884). A. *Krog, artistic director from 1884, revived underglaze painting in blue. *Flambé* and crystalline glazes developed in same period. From 1889 relief decoration used, and *c*1900 production of figures began.
Printed and painted marks.

EKBERG, Josef (1877-1945)

Painter and designer. Worked in Sweden for *Gustafsberg factory (1898-1945).
Painted mark.

ENGELHARDT, Valdemar

Ceramic chemist. In 1880s developed *flambé* and crystalline glazes at Royal *Copenhagen Porcelain factory.
Painted mark.

ERIKSON, Algot (b 1868)

Sculptor and ceramist. Studied at technical school in Stockholm, Sweden. 1882-1920: worked for *Rörstrand porcelain factory, pioneering combination of relief modelling and underglaze painting.
Painted mark.

FINCH, Alfred William (1854-1930)

Painter, graphic artist and ceramist. Born of English ancestry in Brussels, studied at Brussels Academy (1878-80). Co-founder (1884) of *Les Vingt* group of artist-craftsmen in Belgium. From 1897

ran Iris ceramic workshop at Borga, Finland. Ceramics sold in Paris through La *Maison Moderne. From 1902 taught ceramics at school of arts and crafts in Helsinki.
Incised marks.

GAILLARD, Lucien (b 1861)

Jeweller, designer. For biography see METALWORK & JEWELRY. Designed vases for Royal *Copenhagen porcelain factory.
Printed initials.

GUSTAFSBERG

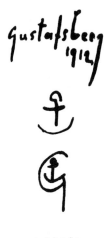

Swedish ceramics factory established (1827) at Gustafsberg, near Stockholm. Under artistic direction of G. Wennerberg in early 20th century, made pottery decorated in *sgraffito* technique with simple floral designs.
Painted marks.

HJORTH, L. (1859-1931)

Ceramist. Worked for several years in Danish ceramics industry before establishing own studio. Made stoneware and porcelain painted by various artists.
Impressed mark.

KÄGE, Wilhelm (1889-1960)

KÄGE

Painter, ceramist. Studied as painter in Sweden, Denmark and Germany. Joined *Gustafsberg factory in 1917, becoming artistic director until 1949.
Painted signature.

KÄHLER, Hermann August
(1846-1917)

Ceramist. Learnt pottery from father at Naestved, Denmark; subsequently worked in Berlin and Zürich before returning (1867) to father's pottery and taking over in 1872. Introduced lustrous glazes, particularly in red. Later production decorated in slip. Employed artists including T. Bindesbøll, O. *Eckmann and K. *Reistrup.
Incised mark.

KROG, Arnold Emil (1856-1931)

Architect, painter, graphic artist and ceramist. Studied architecture at Copenhagen Academy (1874-80), then toured Italy for one year studying *maiolica* techniques. Artistic director of Royal *Copenhagen factory from 1884; director of factory, 1891-1916. Responsible for revival of underglaze painting in shades of blue for which Copenhagen porcelain noted in late 18th century.
Painted mark.

LINDSTRÖM, Carl (1878-1933)

Modeller and decorator. Worked for *Rörstrand porcelain factory.
Painted mark.

NORDSTRÖM, Patrick (1870-1929)

Sculptor and ceramist. Worked for Royal *Copenhagen porcelain factory 1911-22. Then set up own studio at Utterslev, Sweden. Stoneware produced there had seminal influence on Swedish and Danish studio pottery.
Painted mark.

REISTRUP, Karl Hansen (1863-1929)

Painter, sculptor, decorator. After studying at Copenhagen Academy (1881-82), visited Paris (1885-87). On return to Denmark, began working in studio of H. *Kähler.
Painted mark.

RÖRSTRAND PORSLINS FABRIKER

Faience and porcelain manufacturers at Linköping, Sweden. Founded in 1726, produced porcelain from 1880s. *Flambé* and crystalline glazes developed. Firm also made painted and relief-modelled vases. Artists include Alf Wallander, art director from 1897, A. *Erikson and C. *Lindström.
Printed mark.

GLASS

BRITISH GLASS

DRESSER, Christopher (1834-1904)

Architect, designer. For biography see CERAMICS. Designed 'Clutha' glass for Glasgow manufacturers James Couper & Sons c1890.
Etched mark.

MURRAY, Keith (b 1893)

Architect and designer. Born in New Zealand, moved to England in 1925. Designed tableware and individual pieces for Whitefriars Glass Works and *Stevens & Williams from 1932; simple shapes in clear glass with black decoration or restrained cutting. Also designed ceramics.
Stamped or etched mark.

STEVENS & WILLIAMS

Manufacturers at Brierley Hill, Staffordshire. Factory taken over by partners, William Stevens and Samuel Cox Williams, in 1847. Plant modernised in 1890. Frederick Carder, in charge of design studio (1881-1902), introduced to the firm glass engraver, John Northwood (1836-1902), who specialized in cameo-cutting, and established own studio, 1884.
Printed mark.

WEBB, THOMAS, & SONS

Manufacturers at Stourbridge, Worcestershire. Founded in 1837. Wide range of production, including art glass; specialized in cameo glass and 'Rock Crystal'. Firm employed John Northwood (who also worked for *Stevens & Williams) and pupils, brothers Thomas and George Woodall. Some tableware designed by architect, Philip Webb.
Printed and etched marks.

AURENE

See STEUBEN.

FOSTORIA GLASS SPECIALITY Co.

(i) (ii)

Glassworkers founded (1899) at Fostoria, Ohio. In 1910, began production of 'Iris' lustre glass. Factory taken over by General Electric Company and moved to Cleveland, Ohio, in 1917.
Paper label (i) and trademark (ii).

HANDEL CO. INC.

Established (1885) as Eyden & Handel at Meriden, Connecticut; factory became Handel & Co. in 1893. Firm, known as Handel Co. Inc. from 1903, produced wide variety of lamps, often incorporating metal mounts; also manufactured many decorative wares.
Impressed mark.

HAVILAND & Co.

Glass and porcelain retailers in New York.
Printed mark.

IMPERIAL GLASS Co.

Glassworks founded (1901) in Wheeling, West Virginia. Production includes wide range of glassware decorated in variety of techniques, e.g. lustre, iridescence.
Impressed mark.

KEW-BLAS

See UNION GLASS Co.

QUEZAL ART GLASS & DECORATING Co.

Manufacturers. Founded (1901) at Brooklyn, New York, by Martin Bach and Thomas Johnson, former employees of L. C. *Tiffany. Produced iridescent glass, mostly in green, gold and white. Factory closed in 1925.
Cut mark.

STEUBEN

AURENE *Steuben*

Glassworks. Founded (1903) at Corning, New York, by Frederick Carder (1864-1963) and Thomas G. Hawkes. Carder, born in England, had worked for *Stevens & Williams, and emigrated to USA in 1902. Firm produced wide range of glass in styles influenced by work of L. C. *Tiffany, R. *Lalique and E. *Gallé. From 1904, made iridescent glass with trade name 'Aurene'. Firm became Steuben division of Corning Glass Works in 1918. Under artistic direction of A. A. Houghton, J. Gates and S. Waugh, firm concentrated on production of clear crystal wares.
Printed and incised marks.

TIFFANY, Louis Comfort (1848-1933)

(i)

LOUIS C.TIFFANY FURNACES.INC.
FAVRILE

(ii)

Louis C. Tiffany *L.C. Tiffany. Favrile*

Painter, designer, artist-craftsman. Son of jeweller Charles Lewis Tiffany (*Tiffany & Co. Inc.). Studied painting in New York and Paris (1869); travelled to Cairo in 1870. From 1876, experimented with iridescent glass at Brooklyn factory of Louis Heidt, and elsewhere. Collaborated with stained glass painter, John La Farge (1853-1910). Founded Louis C. Tiffany & Company, Associated Artists in 1879; firm carried out interior decoration at White House, Washington, D.C., in 1882. Tiffany Glass Co., formed in 1885. Became Tiffany Glass and Decorating Co. in 1892. Trade name, 'Favrile' adopted in 1894. Firm reorganized (1900) as *Tiffany Studios. Engraved marks.
Marks (i) and (ii) in mosaic.

UNION GLASS Co.

KEW-BLAS

Manufacturers at Somerville, Massachusetts. Produced art glass, sometimes using trade name 'Kew-Blas'. Cut mark.

ARGENTAL

See ST LOUIS-MÜNZTHAL.

ARGY-ROUSSEAU, Gabriel (b 1885)

G.ARGY-ROUSSEAU

Glass artist and ceramist. Studied at
Ecole National Supérieur de Céramique,
Sèvres. Work, from 1918 in *pâte-de-verre*,
includes statuettes made in 1930s after
designs by H. Bouraine.
Incised signature.

ARSALE

Name used by St Louis, manufacturers.
Relief-cut mark.

BACCARAT

Glass manufacturers founded (1764) in
Baccarat (Meurthe-et-Moselle); used
name, Baccarat, from 1822. Established
reputation in 19th century with *millefiori*
glass paperweights. From 1878 produced
tableware, ornamental pieces and
moulded glass.
Stamped or etched mark.

BERGER, Henri (d 1930)

Sculptor, painter, glass designer. Worked
for *Daum Frères *c*1897-1914. From
1908, made models for casting in *pâte-de-
verre* by A. *Walter.
Impressed mark.

BRATEAU, Jules-Paul (1844-1923)

Sculptor, medallist, jeweller, glass artist.
Studied at Ecole Nationale des Arts
Decoratifs, Paris. Made *pâte-de-verre*
from *c*1910.
Gold foil mark.

BROCARD, Philippe-Joseph

Glass painter. Showed glass with enamel
decoration painted in Islamic style at
Paris Exhibition, 1867. From mid 1880s,
archaeological elements of style gave way
to simple floral motifs. By 1884, joined
by son Emile.
Painted mark.

BURGUN, SCHVERER & Co.

Manufacturers of Meisenthal (Alsace-Lorraine). Founded 1711. Firm associated with E. *Gallé between the 1880s and 1890s. D. *Christian among artists employed.
Printed gilt mark.

CAMOT, Eugène

Glass artist working in first quarter of 20th century.
Relief-cut signature.

CARANZA, Amédée, Duc de

Painter, ceramist, glass artist. Born in Istanbul. Until 1875, worked for Longwy faience factory, specializing in *cloisonné* enamel decoration. Also employed by H. A. *Copillet & Cie.
Lustre-painted signature.

CAYETTE, I.

Designer. Worked in Nancy (Meurthe-et-Moselle) during 1920s for L. Majorelle and A. *Walter, among others.
Impressed mark.

CHRISTIAN, Désiré (1846-1907)

Glass maker; established firm, D. Christian & Sohn, in Meisenthal (Lorraine) after working (1885-96) for *Burgun, Schverer & Co. Noted for production of Art Nouveau glass; made iridescent vases, lamps, etc.
Printed mark.

COLOTTE, Aristide (1885-1959)

Glass artist. Born in Baccarat (Meurthe-et-Moselle), moved (1920) to Nancy and opened own workshop there in 1927. Specialized in crystal, deeply cut with geometrical designs typical of 1920s and 1930s.
Engraved signature.

COPILLET, H. A., & CIE

Manufacturers in Noyon (Oise). From 1890s made glass with metal foil insertions and floral decoration. Artists include A. de *Caranza.
Lustre-painted mark.

DAMMOUSE, Albert-Louis (1848-1926)

Sculptor, glass artist, ceramist. For biography see CERAMICS. Working in *pâte-de-verre* from mid 1890s, made vases and bowls with floral decoration. Later, in collaboration with P. *Roche, made plaques moulded in low-relief with figures and landscapes.
Impressed mark.

DAMON, Louis (d 1947)

Glass artist. In 1887, bought Paris firm, Au Vase Etrusque; worked on decoration of glass bought from factory of *Daum Frères.
Incised mark.

DAUM FRÈRES

Manufacturers. Founded (1875) as Verrerie Sainte-Catherine, at Nancy (Meurthe-et-Moselle) by Jean Daum (1825-1883). Artistic direction taken over in 1887 by sons, Jean-Louise-Auguste (1854-1909) and Jean-Antonin (1864-1930), who were strongly influenced by E. *Gallé and established Ateliers d'Art à la Verrerie de Nancy in 1896. Among artists were J. *Gruber, A. *Walter and H. *Berger. 1905-c1930: in collaboration with E. *Brandt, André Groult and Louis Majorelle, firm produced glass with iron mounts. Glass decorated with acid-etched geometrical designs in style of M. *Marinot from 1920s.
Etched, painted or relief-cut marks.

DÉCORCHEMONT, François-Emile
(1880-1971)

Painter, glass artist and ceramist. Son of teacher at Ecole des Art Décoratifs in Paris, studied there, 1893-97. Exhibited stoneware at father's studio (1901) and, in 1902, returned with father to home town of Conches (Normandy), where they built kiln. Began experiments with glass, producing *verres à pâte mince* (from 1903) and *pâte de cristal,* developed between 1905 and 1912. At Paris decorative arts exhibition (1925), exhibited as colleague of designer, Emil-Jacques Ruhlmann, in Hôtel du Collectionneur. In 1934, made glass window for church of St Odile, Paris.
Impressed marks.

DE FEURE, Georges (1868-1928)

G. de Feure

(i)

G de Feure

(ii)

Painter, graphic artist and designer. Born in Paris; became pupil of Jules *Chéret in 1890. Influenced by work of E. *Grasset and Japanese art. Designed scenery for cabaret 'Chat Noir' and contributed illustrations to *Le Courrier Français, Le Boulevard,* etc. With architect, Theodore Vossmann, established Atelier de Feure in Paris. Designed pavilion, L'Art Nouveau Bing (which he also decorated and furnished) in Paris Exhibition (1900). Designs for glass manufactured by *Muller Frères, Hickler company of Darmstadt and *Rheinische Glashütten. Painted (i) and etched (ii) marks.

DELATTE, André

Delatte
NANCY

Glass manufacturers. Founded at Nancy in 1922. Coloured and layer-glass some-times cut with designs of flowers or landscapes.
Painted mark.

DESPRET, Georges

Glass manufacturers and decorators. Founded at Jeumont (Nord) in 1859 by Hector Despret, who was succeeded in firm by nephew, Belgian engineer Georges Despret (1862-1952). Experiments on

pâte-de-verre started in 1890; first example exhibited in Paris (1900). Among artists who worked for firm was sculptress, Yvonne Serruys (b 1874). Painted mark.

DE VARREUX, Camille Tutré

Glass artist. Among directors of *Pantin glasshouse, *c*1910; firm produced etched and cut glass.
Relief-cut mark.

DE VEZ

Pseudonym of C. *de Varreux.

GALLE, Emile (1846-1904)

Glass artist, designer. Son of Charles Gallé-Reinemer (who was partner in workshops for glass decoration, at Nancy from 1845, and faience at Raon l'Etape and Saint-Clément). Studied philosophy, botany and mineralogy. Worked for *Burgun, Schverer & Co. (1866-67). From 1867, had own laboratory for glass-making at Meisenthal (Alsace-Lorraine). Started working on ceramics with father at Saint-Clément in 1870; in same year began collaboration with artist, Victor Prouvé (1858-1943). Ceased work at Saint-Clément in 1874 to concentrate on glass, first shown at Paris exhibition in 1878. Employed wide range of glass techniques, some his own developments. Decorative style influenced by Japanese

Étude de matière

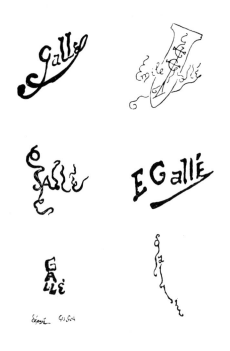

botanist and painter, Tokonso Takashima, who was at Nancy 1885-88; inspired group of Art Nouveau artists, Ecole de Nancy, who adopted styles and techniques used in Nancy workshop in late 19th century. Succeeded in firm by son-in-law, Paul Perdrizet.

Gilt, enamelled, engraved and relief-cut marks.

LALIQUE, René (1860-1945)

R LALIQUE

(i)

[ALIQUE]

(ii)

R. LALIQUE

(iii)

Jeweller, glass artist and designer. In 1876 began two-year apprenticeship as goldsmith. Studied at Ecole des Arts Décoratifs in Paris and in England. After return to France, designed naturalistic jewelry in Paris and, in 1885-86, established own goldsmith's workshop. In 1890s, began use of glass and semi-precious stones in jewelry; exhibited jewelry with crystal glass in 1901. Worked for Samuel Bing; became close friend of A. *Mucha; taught E. *Feuillâtre. Worked from 1902 with long-established glass maker at kiln in Clairefontaine, near Rambouillet, Paris. 1908-09: set up glassworks, Verrerie le-Combs-la-Ville, et Combs (Seine-et-Marne). Abandoned making of jewelry in 1913. Between 1918 and 1922, founded glassworks, Verreries d'Alsace René Lalique & Cie in Wingen-sur-Moder (Bas-Rhin). On death, succeeded as director of firm by son, Marc.

Cut (i) and impressed (ii, iii) marks.

LEGRAS & Cie

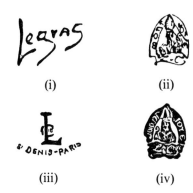

(i)

(ii)

(iii)

(iv)

Verreries et Cristalleries de Saint-Denis, glass manufacturers. Firm of Stumpf, Touvier, Viollet & Cie became two factories (*c*1900), one at La Plaine Saint-Denis and other at *Pantin; both under direction of Francois-Thódore Legras, who succeeded by Charles Legras in 1909. Made glass to designs by R. *Lalique until 1908. After World War I, firms again amalgamated as Verreries et Cristalleries de Saint-Denis et de Pantin Réunies. 'Mont Joye' among trade marks used.
Painted (i), printed (ii-iv) marks.

LÉVEILLÉ, Ernest-Baptiste

Glass artist and ceramist. From 1869, ran glass and ceramics business in Paris. Pupil and colleague of E. *Rousseau, whose studio and firm he bought in 1885. Made coloured, crackled glass with cut and etched decoration.
Engraved mark.

MABUT, Jules

See VERRERIES DE LA PAIX.

MARINOT, Maurice (1882-1960)

Painter, glass artist. Started work in glass in 1911, using as decoration enamel painting in Fauve manner. Glass made to his design at Viard Fils factory near Troyes (Aube). Started own production of glass, exploiting imperfections and impurities for aesthetic effect; sometimes used geometrical ornament. Returned to painting in 1937.
Etched signature.

MICHEL, Eugène (d before 1910)

Glass engraver. Worked as engraver for E. *Rousseau (from 1867) and then E. *Leveillé; started working independently *c*1900. Influenced by Chinese glass of 18th and 19th centuries. Sometimes used metal mounts made by E. Lelièvre.
Engraved mark.

GLASS

MULLER FRÈRES

Glass workshops of Henri and Désiré Muller, pupils of E. *Gallé. Henri became independent c1900, although both brothers worked for *Val St'Lambert, 1906-07. Took over glassworks in Croismare, near Nancy c1910. Established studios for design and decoration at Lunéville (Meurthe-et-Moselle).
Engraved (i, ii, v), etched (iii), painted (iv) and relief-cut (vi) marks.

NAVARRE, Henri (1885-1971)

H.NAVARRE

Sculptor, jeweller, glass artist. Made bowls, vases, etc., with textured surfaces and often in bizarre sculptured shapes. Engraved signature.

NOVERDY, Jean

Jloverdy
France

Glass artist working in Dijon in early 20th century.
Etched mark.

PANTIN, CRISTALLERIE DE

Manufacturers. Glassworks of Stumpf, Touvier, Viollet & Cie; originally established at Pantin in 1855. C. *de Varreux artistic director c1900. Manufactured tableware after designs by Dutch architect, H. *Berlage. Wares marketed through La *Maison Moderne. Firm reunited with *Legras & Cie c1920. Etched mark.

RICHARD

Richard

Unidentified glass artist working in France during first quarter of 20th century.
Relief-cut mark.

SABINO, Maurice-Ernest

Sabino
France.

Glass designer. Studied at Ecole Nationale des Beaux-Arts, Paris. From 1913, designed glass bottles, vases and light fittings.
Engraved mark.

ST LOUIS-MÜNZTHAL

D. Argental

Manufacturers of Münzthal (= Argental, in Lorraine), where glass factory had existed since 1586. In 1829, firm became branch of Compagnie des Verreries at Cristalleries de St Louis. Under direction of Jules Amiet and François Villain (c1900), began to make glass in style influenced by Ecole de Nancy. Later, tableware made to designs by M. *Dufrêne and artist, Marcel Goupy (b 1886).
Relief-cut mark.

SALA, Jean (b 1895)

J. Sala

Glass artist. Born in Spain. Made vases, bowls, etc., in Functionalist style, using bubbled, blue-green glass.
Engraved signature.

SCHNEIDER, CRISTALLERIE

Glass manufacturers. Founded at Epinay-sur-Seine in 1913 by Charles Schneider (1881-1962), who had studied at Ecoles des Beaux-Arts in Nancy and Paris, meanwhile working as designer for E. *Gallé and *Daum Frères. Created series of vases and bowls (*intercalaires*) inspired by work of French Impressionistic painters; also made glass with iron mounts by furniture maker, Louis Majorelle, for Daum (1924-30). 'Le Verre Français' sometimes used as trade name.
Engraved, scratched and etched marks.

THIAUCOURT

Thiaucourt

Glass artist working in France in first quarter of 20th century.
Engraved mark.

THURET, André (1898-1965)

Glass artist. Worked in glass industry before going (1926) to Conservatoire National des Arts et Métiers, Paris; experimented there in every aspect of glass technology. Glass vases bubbled and particoloured.
Engraved signature.

VALLÉRYSTHAL ET PORTIEUX, VERRERIES REUNIES DE

Manufacturers. Glass factories at Vallérysthal (Lorraine), founded 1836, and at Portieux (Vosges), founded 1705, united in 1872 and produced art glass from c1898. Some pieces designed by F. A. Otto Kruger and B. *Paul of Munich. Incised and gilt marks.

VERLYS, A.

Glass artist. Made glass with relief decoration in style of R. *Lalique during 1920s and 1930s.
Moulded mark.

VERRERIE DE LA PAIX

Paris retailers of glassware run by Jules Mabut. Firm commissioned painter and ceramist H. A. L. *Laurent-Desrousseaux to design floral decoration for glass shown in Paris Exhibition, 1900.
Etched mark.

WALTER, Alméric (1859-1942)

Glass artist and ceramist. Studied at Ecole Nationale de la Manufacture de Sèvres. With Gabriel Lévy, began working in *pâte-de-verre,* c1902. Made statuettes, medallions, vases, etc. While working for *Daum Frères (1908-14), made *pâte-de-verre* after models by H. *Berger. In 1919, established own workshop at Nancy to make *pâte-de-verre.* Among designers and modellers were Joseph *Chéret, J.-B. Descomps, and I. *Cayette.
Impressed mark.

VAL ST LAMBERT,
CRISTALLERIES DU

Factory near Liége, founded in 1825.
Major producer of hollow ware in
Belgium during 19th century. Under
direction of Georges Desprez, firm began
making art glass in style of E. *Gallé.
Between 1897 and 1903, P. *Wolfers
associated with firm; *Muller brothers
employed 1906-07.
Etched marks.

COPIER, Andries Dirk (b 1901)

(i) (ii)

SERICA COPIER

Designer. Joined Royal Dutch Glass Works at Leerdam, near Rotterdam in 1914; participated in creation of 'Unica' and 'Serica' lines. Leader of 'Unica' studio from 1923.
Engraved marks on Unica (i) and Serica (ii) glass.

DE BAZEL, K. P. C. (1869-1923)

Architect, designer. Commissioned (1915) to design glass tableware for manufacture by Royal Dutch Glass Works at Leerdam, near Rotterdam. Also designed furniture.
Engraved mark.

DE LORM, Cornelis (1875-1942)

Designer. Worked for Royal Dutch Glass Works at Leerdam, near Rotterdam, designing services and vases of extreme simplicity from 1917.
Etched mark.

LANOOY, Christian J. (1881-1948)

Glass artist, ceramist. For biography see CERAMICS. Designed glass for Royal Dutch Glass Works, Leerdam, near Rotterdam, during 1920s.
Engraved mark.

BAAR, Lotte (b 1901)

Glass engraver. Worked at Breslau School of Industrial Art. Engraved monogram.

BENNA, Edgar (b 1899)

Glass engraver. Foreman and instructor at Breslau School of Industrial Art from 1918. Engraved monogram.

GROSSHERZOGLICHE EDELSGLASMANUFAKTUR

Grand Ducal Fine Glass Factory Founded by Grand Duke Ernst Ludwig of Hesse-Darmstadt at Darmstadt (1907) with J. E. *Schneckendorf as director. Painted, gilt or stamped mark.

HECKERT, Fritz

F.H.
(i) *Heckert.* (ii)

Petersdorfer Glashütte, Petersdorf, Silesia. Glass manufacturers founded by Fritz Heckert in 1866. Designers included M. *Rade. Engraved (i) and etched (ii) marks.

JOHN, Marie Elisabeth (b 1903)

M]

Glass engraver. Worked at Breslau School of Industrial Art. Engraved monogram.

KLOSE, Arthur (b 1898)

*̵
R

Glass Engraver. Worked at Breslau School of Industrial Art. Engraved monogram.

KOEPPING, Karl (1848-914)

Painter, engraver, glass designer. Worked briefly with F. *Zitzmann (1895-96) who made glass to his designs. Later designs executed at technical college in Ilmenau, Thuringia. Signature in lustre.

LOWENTHAL, Arthur (b 1879)

Glass engraver of Viennese origin.
Worked in Berlin.
Engraved monogram.

MAUDER, Bruno (1877-1948)

Painter, glass designer. Studied at
Munich School of Industrial Art (1899-
1901). From 1910, director of Technical
School, *Zwiesel, Bavaria.
Gilt mark.

PECHSTEIN, Max (1881-1955)

Painter, sculptor, graphic artist, glass
painter. Studied at Kunstgewerbeschule
and Academy in Dresden. Associated
with painters of Die Brucke. From 1908
lived in Berlin. Designed stained glass
windows.
Painted initials.

RADE, Max (1840-1917)

Designer. Professor at School of
Industrial Art, Dresden. Designed enamel
decoration for glass manufacturers F.
*Heckert and C. *Schappel.
Engraved monogram.

RHEINISCHE GLASHÜTTEN

Glass manufacturers at Köln-Ehrenfeld
from 1864 to 1931.
Etched mark.

RIGOT, Edmund (b 1885)

Glass engraver. Worked for *Villeroy
& Boch until 1934.
Etched signature.

SCHNECKENDORF, Josef Emil
(1865-1949)

Glass artist, jeweller, sculptor. Studied
at Munich Academy from 1890. In 1907,
appointed director of newly founded
*Grossherzogliche Edelsglasmanufaktur
at Darmstadt.
Painted, gilt, or stamped monogram.

SÜSSMUTH, Richard (b 1900)

Glass cutter. Trained at Dresden Academy of Industrial Art. Started own factory in 1924.
Engraved monogram.

VILLEROY & BOCH

Ceramic and glass manufacturers founded at Mettlach in 1842. Glassworks at Wadgassen.
Etched mark.

VITTALI, Otto (b 1872)

Glass painter. Studied at Karlsruhe, Munich and Frankfurt-am-Main.
Painted signature.

VON EIFF, Wilhelm (1890-1943)

W.v.E

Glass designer and engraver. At Stuttgart Art School, studied from 1913 and became professor in cutting and engraving on glass in 1922.
Engraved initials.

VON POSCHINGER, Ferdinand

Glashüttenwerke Buchenau, near Zwiesel, Bavaria. Glass manufacturers. Manager from 1867 to 1921 was Ferdinand Benedikt von Poschinger. Designers included Julius Diez and R. *Riemerschmid.
Engraved marks.

WENZEL, Moritz

XXX

Glass dealers in Breslau.
Engraved monogram.

ZITZMANN, Friedrich (1840-1906)

Glass blower. Made glass in historical styles until brief association with K. *Koepping (1895-96) in Berlin. Then settled in Wiesbaden and worked in Koepping's style.
Signature in lustre.

GLASS

ZWIESEL

Staatliche Fachschule für Glasindustrie und Holzschnitterei (Government Technical School for Glass Manufacture and Woodcarving) at Zwiesel in Bavaria. From 1910, under direction of B. *Mauder, produced glass usually decorated with enamel-painting or gilding.
Engraved monogram.

BECKERT, Adolf (1884-1929)

Glass artist. Studied at Prague Kunst-gewerbeschule and at Fachschule *Haida; also in Munich. Artistic director at *Loetz factory (1909-11). Taught at Fachschule *Steinschönau (1911-26); director from 1918.
Monogram carved in relief.

CONRATH & LIEBSCH

Glass decorators; workshops at Steinschönau, northern Bohemia.
Engraved mark.

DRAHOŇOVSKY, Josef (b 1877)

Engraver, worked on glass and precious stones. In 1908 appointed professor at Prague Kunstgewerbeschule.
Engraved initials.

EISELT, Arnold

Glass artist. Designed and engraved decoration for Fachschule *Haida and taught there 1907-14; also worked for Fachschule *Steinschönau and J. & L. *Lobmeyr.
Engraved monogram.

EISELT, Paul

Glass engraver. Worked at Fachschule *Steinschönau, northern Bohemia.
Engraved initials.

GOLDBERG, Carl

Workshops for glass decoration. Founded at Haida, Bohemia, in 1881. Carried out cut, etched and silvered decoration.
Relief-cut mark.

HAIDA K.K. FACHSCHULE

Industrial school founded (1869) in Haida, Bohemia. Established workshop for glass engraving (1881-82) and for glass painting (1882).
Engraved and etched marks.

HARRACH, GRÄF

Harrach

Glassworks founded (1630) at Neuwelt. Designs in modern style produced under management of Bohdan Kadlec (1884-1900) and Jan Mallin (1901-13). Julius Jelinek director of design office.
Relief mark.

HOFFMANN, Josef (1870-1956)

PrOF, HOFFMANN

Architect, designer. For biography see METALWORK & JEWELRY. Designed glassware for J. *Oertel & Co., C. *Schappel, *Meyr's Neffe, K. *Moser, *Loetz factory, etc.
Engraved mark.

KIRSCHNER, Maria (1852-1931)

M

Painter and designer. Bohemian, trained in Prague and Munich. From 1887 worked in Berlin, specializing in painting and designs for crafts. Designed and made embroidery c1900; designed glass for *Loetz factory c1903-14.
Cut monogram.

KRASNA, R.

R Krasna

Glassworks near Wallach-Meseritsch. Produced decorated glass for firm of S. Reich & Co., Vienna.
Etched mark.

KROMER, Emil

E K

Glass engraver. Worked at Fachschule *Steinschönau.
Engraved initials.

KULKA, Wenzel

Firm making cut crystal glass at Haida, Bohemia, in first half of 20th century.
Etched mark.

LOBMEYR, J. & L.

Manufacturers. Founded (1823) in Vienna. Designers in early 20th century included J. *Hoffmann and M. *Powolny. In 1918, branch established at Steinschönau, Bohemia, by Stephen Rath (b 1876); employed daughter, Marianne Rath (b 1904) as designer. Engraved mark.

LOETZ, GLASFABRIK JOHANN
LOETZ WITWE

 (i)

Loetz Austria (ii)

Loetz (iii)

Glass manufacturers. Johann Loetz (1778-1848) bought glass factory at Klostermühle shortly before 1840; succeeded in business by widow and, in 1879, by grandson M. R. *Von Spaun. Under management of Eduard Prochaska (1885-1914), firm specialized in production of coloured and iridescent glass. from 1880s. Through firm of E. Bakalowits, Vienna retailers of Loetz glass, commissioned designs from K. *Moser and pupils. From 1902 Berlin designers M. *Kirschner and L. Bauer associated with factory. Under art direction of A. *Beckert (1909-11), produced glass with etched floral decoration in French style. Employed leading *Wiener Werkstätte designers, e.g. J. *Hoffmann, D. *Peche, M. *Powolny and O. *Prutscher. Engraved (i, ii) and relief-cut (iii) marks.

MASSANETZ, Karl (1890-1918)

Glass artist. Studied at Fachschule *Steinschönau and Vienna Kunstgewerbeschule (1908-12). Set up own workshop at Steinschönau, Bohemia. Painted mark.

MAX, Hugo

M.H.

Porcelain painter, glass engraver. Craftsman and instructor at Fachschule *Steinschönau, 1896-1925. Engraved initials.

MEYR'S NEFFE

Firm of glass manufacturers established 1815-16. In early 20th century, workshops at Adolf, Böhmerwald, manufactured table glass to designs by O. *Prutscher, K. *Moser, etc. Amalgamated with firm of L. *Moser & Sons in 1922.
Engraved mark.

MOSER, Kolo (1868-1919)

Designer, decorative artist. For biography see CERAMICS. Designed for firms of Bakalowits, Kralik, *Loetz and other glass factories.
Engraved monogram.

MOSER, Ludwig & Söhne

Glass manufacturers. Founded by Ludwig Moser (1833-1916) at Carlsbad, Bohemia. Specialized in layer-glass with etched decoration. Acquired *Meyr's Neffe glassworks in 1922.
Scratched marks.

MULLER, Rudolf

Glass artist. Worked at Fachschule *Haida and Fachschule *Steinschönau.
Engraved initials.

NECHANSKY, Arnold (1888-1938)

Architect, designer. Studied at Vienna Kunstgewerbeschule. In 1919, visited School of Handicrafts at Charlottenburg, Berlin. Designed glass for *Loetz factory and *Lobmeyr.
Painted mark.

OERTEL, Johann & Co.

Glass manufacturers founded (1869) at Haida, Bohemia. Founder and manager, Johann Oertel (d 1909), succeeded by son. Produced many pieces to designs by staff and students at Fachschule *Haida.
Printed mark.

PALLME KÖNIG, GEBRÜDER

Manufacturers. Firm of Pallme & Ullman, established (1786) at Steinschönau, Bohemia, taken over by brothers Josef and Theodor Pallme in 1886. Factories at Steinschönau and Kosten produced wide range of decorative glass, particularly iridescent ware. Printed paper label.

PECHE, Dagobert (1889-1923)

ARCH.D.PECHE.
LOETZ.

Designer, decorator artist. For biography see CERAMICS. Designed glass for *Loetz factory and *Wiener Werkstätte. Painted mark.

POWOLNY, Michael (1880-1949)

Ceramist, designer. For biography see CERAMICS. Designed glassware for J. & L. *Lobmeyr and *Loetz factory. Engraved mark.

SCHAPPEL, Carl

CARL
SCHAPPEL
HAIDA

Glass manufacturers founded (1857) at Haida, Bohemia, by Carl Schappel (d 1868). On Schappel's death, firm bought by Werner & Kroebs. J. Georg Stier and Johann Wanderle became managers in 1896. Designers included M. *Rade and J. *Hoffmann. Printed mark.

STEINSCHÖNAU, K.K. FACHSCHULE

Industrial school founded (1839) at Steinschönau in northern Bohemia. Received grant from Imperial funds in 1855. By 1880 had workshops for glass engraving and painting. Engraved mark.

GLASS

VON SPAUN, Max Ritter (d 1909)

Glass artist. Director of *Loetz
glassworks (1879-1908), enlarged and
modernized factory.
Painted signature.

WELTMANN, Milla

MILLA
WELTMANN
LOETZ.

Designer. Supplied designs for *Loetz
factory and J. & L. *Lobmeyr.
Painted mark.

BERGQVIST, Knut

Craftsman. Worked for *Orrefors glassworks from c1915.
Engraved initials.

GATE, Simon (1883-1945)

Glass artist. Appointed designer at *Orrefors factory in 1917. Designed both shapes and multicoloured or engraved decoration.
Engraved monogram.

HALD, Edward (b 1883)

Painter, glass artist. Studied painting under Henri Matisse in Paris. After designing for *Rörstrand porcelain factory, joined *Orrefors glassworks in 1917.
Engraved initial marks.

KOSTA

Glassworks. Founded (1742) at Kosta, near Karlskrona, Småland. From 1897 made glass in style of E. *Gallé. Designers included K. *Lindeberg and ceramic artists, G. Wennerberg and Alf Wallander. In 1917 designer, Edwin Ollers became artistic director, introducing new generation of artists and new style of simple cut decoration.
Relief-cut mark.

LINDEBERG, Karl (1877-1931)

Designer and painter of glass. Worked for *Kosta 1902-31.
Engraved signature.

ORREFORS

Glassworks; founded 1898. Made decorative glassware from 1915; designers included E. *Hald and S. *Gate.
Engraved mark.

GLASS

REIJMYRE GLASBRUK A. M.

Reijmyre
Suède

Manufacturers. Founded (1810) in Läu Östergötland, near Norköping by Johan Jacob Graver. New factory set up (1865) with Josna Kjellgren as director. Youngest son, Sten Kjellgren, took over technical management (1895), becoming general director in 1900. Firm dissolved 1926.
Incised mark.

IMPERIAL RUSSIAN
GLASS FACTORY

Glasshouse founded (1777) at St
Petersburg by Prince Potemkin. In
1890 amalgamated with Imperial
Porcelain factory. Until *c*1900 produced
glass decorated with motifs of Russian
folklore; subsequent decoration in style
of E. *Gallé and glassworks of
*Baccarat (Meurthe-et-Moselle, France).
Cut mark.

METALWORK & JEWELRY

ARTIFICERS' GUILD

Producers and retailers of metalwork and other crafts. Founded (1901) in London by N. *Dawson; taken over (1903) by Montague Fordham and designer, Edward Spencer. Silver, copper and other metalwork made mainly to Spencer's designs. London retail outlet in Forham gallery, Maddox Street (from 1904), later moved to Conduit Street; branch opened in Cambridge. Closed in 1942. Stamped mark on silver.

ASHBEE, Charles Robert (1863-1942)

Architect, designer and writer. Trained as architect under G. F. Bodley. Prominent figure in Arts & Crafts movement, founded *Guild of Handicraft. Designed silver, jewelry and furniture for production by Guild. Member of Arts & Crafts Exhibition Society and, from 1897, Art Workers' Guild (Master in 1929); exhibited at Vienna Secession (1900), and in exhibition of British decorative arts in Paris (1914). Wrote several treatises on theory of design and craftsmanship. Stamped initials.

BENHAM & FROUD

Manufacturers of copper and brass wares, operating in London in mid-late 19th century. Produced copper kettles to designs by C. *Dresser. Stamped mark.

BENSON, William Arthur Smith (1854-1924)

Architect, designer, metalworker. Studied architecture under Basil Champneys, 1877-80. Encouraged by William Morris, opened workshop (1880) for production of turned metalwork. Soon afterwards, opened factory in Hammersmith, London, ceasing production on retirement in 1920. Also designed furniture (for W. *Morris & Co.), cast iron and wallpapers. Stamped marks.

BIRMINGHAM GUILD OF
HANDICRAFT

Association of metalworkers founded in
1890 by Arthur S. Dixon (1856-1929);
became limited company in 1895. Silver
and base metals produced mainly to
designs by Dixon and Claude Napier-
Clavering. Merged with other firms of
metalworkers in 1910 and 1919-20. In
1920s specialized in architectural
ironwork; production now mainly
agricultural machinery and light
engineering parts.
Stamped mark.

BOYTON, Charles & Son

Firm of manufacturing silversmiths
established in London c1900. After death
of Charles Boyton in 1904, business
carried on by widow and son. Produced
wide range of cutlery, cruets etc., in
geometrical shapes.
Stamped marks.

CARR, Alwyn C. E.

See RAMSDEN & CARR.

CENTURY GUILD

Group of designers and craftsmen centred
round architectural partnership of A.
*Mackmurdo and H. *Horne, formed
c1882. Work includes furniture,
metalwork, textiles and interior
decoration. Copper, brass and pewter
wares made by George Esling and
Kellock Brown.
Hammered mark.

CONNELL

Firm of manufacturing silversmiths.
William George Connell, director until
death in 1902, succeeded by son, George
Lawrence Connell. Wide range of
domestic silverware made in floral Art
Nouveau style.
Stamped marks.

COOPER, John Paul (1869-1933)

Silversmith and jeweller. Trained as architect in office of John D. Sedding. Made ornamental silver and jewelry, often decorated with sculpted figures and semi-precious stones; also used shagreen, ivory, etc. First exhibited silver in 1894. Stamped marks.

COURTHOPE, Frederick

Silversmith. Working in late 19th and early 20th centuries, made silverware, including furniture fittings. Stamped initials.

CUZNER, Bernard (1877-1956)

Silversmith and jeweller. Studied at art school in Redditch, Worcestershire, and Vittoria Street School for Jewellers and Silversmiths, Birmingham. Among designers of Cymric silver for *Liberty & Co. c1900. Head of metalwork department, Birmingham School of Art, 1910-42. Wrote *A Silversmith's Manual* (1935).
Stamped initials.

CYMRIC

See LIBERTY & CO.

DAWSON, Nelson (1859-1942)

Painter, silversmith, jeweller, metalworker. Trained as architect; studied painting at South Kensington Schools in London. In 1891, took up metalwork, studying enamelling under A. *Fisher. Set up workshop, making silver, jewelry etc. often decorated with enamel by wife, Edith Robinson (married 1893), who often incorporated letter D in designs. Founder (1901) and art director (until 1903) of *Artificers' Guild. Abandoned metalwork for painting, 1914. Stamped mark.

DIXON, James & Sons

Manufacturers of silver and plate. Established (1806) in Sheffield, Yorkshire, as Dixon & Smith. Produced

silver and plated wares for Felix Summerly's Art Manufacturers c1850, and later to designs by C. *Dresser (from 1870s).
Stamped marks.

DRESSER, Christopher (1834-1904)

Architect, designer. For biography see CERAMICS. Designed silver and plate for J. *Dixon & Son, *Elkington & Co., *Hukin & Heath; metalwork for *Benham & Froud, Chubb & Co., Perry & Co.; cast iron for Coalbrookdale Co.
Stamped marks.

ELKINGTON & Co.

Manufacturers of silverware, plate and other metalwork. Established in Birmingham in first half of 19th century. Pioneered electro-plating process in 1830s and 1840s. Experimented with *champlevé* and *cloisonné* enamel technique in 1860s. Designs for enamelwork and silverware inspired by Japanese applied arts through 1870s and 1880s; simple geometrical shapes designed in same period by C. *Dresser. Domestic silver decorated with enamels in Arts & Crafts taste c1900. Silver made during 1920s and 1930s to designs by Jean Puiforçat, French silversmith.
Stamped marks.

FISHER, Alexander (1864-1936)

Painter, sculptor, silversmith. Studied painting at South Kensington Schools, London (1881-86), later metalwork and enamelling in Italy and France. Established London workshop and taught (1896-99) at Central School of Arts & Crafts. Set up school of enamelling at London studio, 1904. Silver and jewelry often decorated with enamels and figurative sculpture. Pupils include N. *Dawson.
Stamped mark.

GASKIN, Arthur Joseph (1862-1928)

(i)

(ii)

Painter, illustrator, silversmith and jeweller. Studied at Birmingham School of Art, becoming member of Birmingham Group of Painters and Craftsmen. Designed and produced jewelry with wife, Georgina Cave France from 1899. Among designers of Cymric silver for *Liberty & Co. Head of Vittoria Street School for Jewellers and Silversmiths, Birmingham, 1902-24.
Engraved (i) and engraved or pricked (ii) initials.

GOLDSMITHS' & SILVERSMITHS' Co.

Designers, manufacturers and retailers of gold, silver and jewelry established (1890) in London by William Gibson. Designers include H. *Stabler. Firm taken over in 1952.
Stamped mark.

GUILD OF HANDICRAFT

Guild of artist-craftsmen founded (1888) by C. R. *Ashbee and operating in East London from 1890, with retail outlet in Mayfair. Silverwork in simple shapes, jewelry often in styles influenced by Art Nouveau; also undertook cabinet making, leatherwork, etc. Guild moved to Chipping Campden, Gloucestershire, in 1902; liquidated 1907.
Stamped marks.

HART, George (b 1882)

HART & HUYSHE
CAMPDEN. GLOS

Silversmith and designer. Member of *Guild of Handicraft; continued to work in Chipping Campden, Gloucestershire, after Guild's closure in 1907.
Stamped mark.

HASELER, W. H. & Co.

Manufacturers of silver, jewelry and other metalwork. Established (1870) in Birmingham. In partnership with *Liberty & Co. until 1927, made Cymric silver (launched 1899) and Tudric pewter (from 1903).
Stamped mark.

HORNE, Herbert Percy (1864-1916)

Architect, designer. Studied architecture and design under A. *Mackmurdo, later partner and co-founder of *Century Guild, c1882. Designed metalwork, wallpapers, textiles, etc.
Hammered monogram.

HUKIN & HEATH

(i) (ii)

Manufacturers of silver and plate. Established (1879) in Birmingham. Wide range of domestic ware designed c1880 by C. *Dresser. Firm ceased operation in 1953.
Stamped marks on silver (i) and plate (ii).

HUTTON, William, & Sons

Manufacturers of silver, silver-plate, Sheffield plate, pewter and copper wares. Established (1800) in Birmingham by William Hutton (1774-1842); new factory opened in Sheffield, Yorkshire, 1832. Under T. Swaffield Brown, art director 1880-1914, produced range of Art Nouveau silver (many pieces designed by Kate Harris) and enamelled copper vases. Firm liquidated in 1920s.
Stamped mark.

JONES, Albert Edward (1879-1954)

Silversmith. Member of family working as blacksmiths in Birmingham from 1870s, started making silver and jewelry in 1902. Wide range of handmade beaten silver often decorated with turquoise stones. Head of Sir John Cass Technical Institute, London, from c1905.
Stamped initials.

METALWORK & JEWELRY

KESWICK SCHOOL OF
INDUSTRIAL ART

K
S I
A

Classes for instruction in metalwork started as evening institute near Keswick, Cumbria, in 1884; daytime classes began with appointment of H. *Stabler as full-time director, 1898-99. Produced range of domestic utensils and decorative ware in silver, copper, brass and other alloys. Stamped mark.

LEGROS, Alphonse (1837-1911)

A. Legros.

Painter, sculptor, graphic artist, medallist. Born in France, studied at Ecole des Beaux-Arts, Paris. Settled in London, 1863; Slade Professor at University College 1876-92. Engraved signature.

LIBERTY & Co.

CYMRIC

ENGLISH PEWTER
0 2 2 1

MADE BY LIBERTY & CO

Retail firm founded (1875) in London by Arthur Lasenby Liberty. Stockists of wide range of oriental crafts; from 1880s commissioned designs for metalwork, fabrics, furniture, ceramics, etc. In partnership with W. H. *Haseler & Co. promoted Cymric range of silver; designs, by artists including B. *Cuzner, A. *Jones, J. *King and A. *Gaskin, of Celtic inspiration. Pewterware produced (c1903-c1938) under trade name, Tudric, similar in design. Stamped marks.

MACKINTOSH, Margaret Macdonald
(1865-1933)

Margaret
Macdonald
Mackintosh

Designer, metalworker and embroideress. While studying at Glasgow School of Art, met husband, C. R. *Mackintosh (married 1900). Designed and made decorative metalwork. Collaborated with husband on design and production of furniture, metalwork, etc. Engraved signature.

MACKMURDO, Arthur Heygate
(1851-1942)

M

Architect, designer of metalwork,
furniture, wallpapers, textiles, etc.
Studied architecture under James Brooks,
and drawing at school of John Ruskin in
Oxford. With H. *Horne established
*Century Guild c1882.
Hammered initial.

MARKS, Gilbert Leigh (1861-1905)

GM

Silversmith and metalworker. After
working for silver manufacturers (from
1878), established workshop (1885)
producing metalwork in Croydon,
Surrey. Hand beaten silver, copper and
pewter often have embossed decoration.
Stamped mark on silver.

McNAIR, J. Herbert (fl c1890-c1910)

J.HERBERT
McNAIR

Architect, designer. Worked in Glasgow
architect's office with C. R. *Mackintosh.
Taught at Liverpool Art School. Designed
furniture, often with metalwork
decoration, and decorative copper panels.
Engraved signature.

MURPHY, H. G. (1884-1939)

HGM

Artist craftsman, silversmith and
jeweller. Apprenticed to H. *Wilson,
1898. Worked with German silversmith,
Emil Lettré, 1912 in Berlin. Taught in
London at Royal College of Art (from
1909) and Central School of Arts &
Crafts (principal from 1937). Inspired
by Arts & Crafts movement until 1920s,
then adopted style which was more Art
Deco in feeling.
Stamped initials.

MURRLE BENNETT & Co.

Manufacturers of low-priced jewelry in
gold and silver with gems, often to designs
of German origin. Operated c1900.
Stamped marks.

PEARSON, John (fl early 20th century)

Silversmith, metalworker. Worked with
*Guild of Handicraft, and craft guild in
Newlyn, Cornwall. Made plaques, boxes
in beaten silver or copper.
Stamped mark on silver.

POWELL, James, & Sons

London glasshouse, manufacturers of
silver mounts. Under artistic direction of
Harry J. Powell (1880-1914) made range
of vessels in green glass with silver mounts
in style inspired by Arts & Crafts
movement.
Stamped mark.

RAMSDEN & CARR

Partnership of goldsmiths and silver-
smiths, Omar Ramsden (1873-1939) and
Alwyn C. E. Carr (1872-1940), who met
while students at Sheffield School of Art,
studied at South Kensington Schools and
travelled (1896-98) in Italy. On return to
London, set up in partnership,
specializing in production of ceremonial
gold and silver, often with enamel
decoration. Dissolved partnership in
1919, both continuing to work
independently.
Stamped and engraved marks.

REYNOLDS, William Bainbridge
(1855-1935)

Architect and silversmith. Trained as
architect under G. E. Street (1871-74);
also worked in officer of J. P. Seddon.
Joined firm of *Starkie Gardner in 1883;
established own workshop c1894. Made
silver and ecclesiastical furnishings in
neo-Gothic style.
Stamped mark.

STABLER, Harold (1872-1945)

Designer, metalworker. Studied at Kendal
Art School, Cumbria, at first as cabinet
maker, then in metalwork and
enamelling. Became director of
metalwork classes at *Keswick School of
Industrial Art (1898), soon leaving to

teach in metalwork department of Liverpool University School. Taught at Sir John Cass Technical Institute in London from 1906; head of art department 1907-37. Soon after arrival in London opened Hammersmith studio, carrying out decorative work in silver and enamel and, with wife Phoebe, sculptures in ceramics and bronze. Founder member of Design & Industries Association. Designed silver manufactured by *Goldsmiths' & Silversmiths' Co., Wakely & Wheeler and Adie Bros; also stainless steel for Firth Brown.
Stamped mark.

STARKIE GARDNER & Co.

Manufacturers of metalwork operating in London in first half of 20th century. Worked in silver and other metals, including architectural wrought-iron. Stamped mark on silver.

TUDRIC

See LIBERTY & CO.

WILSON, Henry J. (1864-1934)

Architect, sculptor, metalworker and jeweller. Chief assistant to architect, J. D. Sedding, took over Sedding's London practice in 1891. Became interested in metalwork c1890; joined Art Workers' Guild in 1892. Established own workshop. Teacher at Central School of Arts & Crafts (from 1896) and Royal College of Art (from 1901). Moved to Paris in 1922; worked in France, Italy and USA.
Monogram.

AMERICAN METALWORK & JEWELRY

GLESSNER, Frances M.

Silversmith. Worked in Chicago, Illinois, c1900, making hand beaten silver vessels. Stamped mark.

GORHAM CORPORATION

GORHAM

(i)

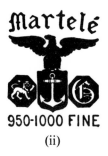

950-1000 FINE

(ii)

Manufacturers of silver, silver, silver plate, bronze and other metalwork, and furniture. Established as jewellers in Providence, Rhode Island, c1815-18, firm became Gorham & Webster in 1831 and, in 1860s, opened New York sales office; corporation from 1865. Design workshop set up in late 19th century executed Art Nouveau jewelry designs by English silversmith, William Codman, sold under trade name, 'Martelé'. Firm bought *Whiting Manufacturing Co. in 1905. Stamped marks; (i) used on art bronzes.

JARVIE, Robert R. (1865-1940)

Silversmith and metalworker. Working in Chicago, Illinois, (c1890-c1920) designed and made silverware, including trophies; also noted for candlesticks made in copper.
Scratched signature.

MERIDEN SILVER PLATE Co.

Manufacturers of silver-plated wares. Founded (1869) at Meriden, Connecticut, by Charles Casper and others. Became part of International Silver Co. in 1898. Produced hollow-ware in designs influenced by Japanese.
Stamped marks.

REED & BARTON

REED & BARTON

Manufacturers of silver and nickel-plated wares. Firm dating from 1820s underwent changes in management; name registered in 1890. Influenced by English styles; at period of Aesthetic Movement produced wares of Japanese inspiration.
Stamped marks.

TIFFANY & Co. Inc.

TIFFANY & COMPY

TIFFANY & Co
550 BROADWAY

Manufacturers of silver and other metalwork. New York company, founded by Charles L. Tiffany (1812-1902), imported jewelry from Europe and began manufacture in 1848; taken over by L. C. *Tiffany in 1902. Under artistic direction (from 1868) of Edward C. Moore, son of manufacturing silversmith John C. Moore, many designs and techniques of silver reflected influence of Japanese metalwork.
Stamped marks.

TIFFANY STUDIOS

TIFFANY STVDIOS
NEW YORK

Workshops for manufacture of metalwork, pottery, glass, etc. Tiffany Glass and Decorating Co., forerunner of Studios, founded (1879) in New York by L. C. *Tiffany son of president of *Tiffany & Co. Inc. Much furniture, glass and metalwork shows influence of Persian art, reflecting time spent by L. C. Tiffany travelling in Middle East following study in Paris. Firm continued until 1936, after withdrawal of Tiffany in 1919.
Stamped mark.

WHITING MANUFACTURING Co.

Firm of silversmiths and jewellers founded (1866) in Newark, New Jersey. Made silver with Japanese inspired decoration. Purchased (1905) by *Gorham Corporation and moved to Providence, Rhode Island in 1925.
Stamped mark.

FRENCH METALWORK & JEWELRY

BARBEDIENNE

Foundry, metalwork factory. Founded (1838) in Paris by François Barbedienne. Cast in bronze work by many leading French sculptors during latter half of 19th century and early 20th century. Firm closed in 1953.
Stamped marks.

BERNARD, Joseph (1866-1931)

Bernard

Sculptor, graphic artist. Studied at Ecoles des Beaux-Arts in Lyons and Paris; worked at Boulogne-sur-Seine.
Engraved signature.

BISEGLIA, Mario

cire perdue BISCEGUE

Bronze foundry operating in Paris early in 20th century.
Stamped mark.

BORREL, Alfred (b 1836)

A.BORREL

Sculptor, medallist. Studied under father, medallist Maurice Borrel (1804-82), and at Ecole des Beaux-Arts.
Engraved signature.

BOTTÉE, Louis Alexandre (1852-41)

Lˢ BoTTÉE

Sculptor, medallist. Studied at Ecole des Beaux-Arts in Paris under H. *Ponscarme. After visiting Rome, returned to Paris and worked chiefly as medallist.
Engraved signature.

BOUCHERON, MAISON

B

Jewellers working in Paris, with branches in Biarritz, London and New York. Founded (1858) by Frédéric Boucheron (1830-1902). Specialized in jewelry set with diamonds and other precious stones, using motifs popular in 18th century; also produced designs in Art Nouveau and modern styles in early 20th century.
Stamped mark.

BRANDT, Edgar (b 1880)

E BRANDT

Designer, metalworker. Early work shown in Paris Exhibition, 1900. In 1920s noted for decorative wrought-iron panels, sometimes incorporating brass, copper or other metals. Designed decorative light fittings for manufacture in series.
Stamped mark.

CALLOT, Jacques

J Callot

Sculptor and medallist. Born at Blaru (Seine-et-Oise). Exhibited at Paris Salon from 1894. Modelled bronze statuettes and vessels, as well as many portrait medallions.
Signature.

CARABIN, François Rupert (1862-1932)

R. Carabin

Sculptor, medallist, graphic artist, designer. With Georges Seurat, Paul Signac and Albert Dubois-Pillet founded Société des Artistes Indépendants in Paris, 1884. Modelled statuettes for reproduction in bronze and pottery.
Signature.

CARDEILHAC

Cardeilhac. Paris

Firm of silversmiths founded (1802) in Paris by Vital-Antoine Cardeilhac. Under direction, from 1860, of Ernest Cardeilhac (d 1904), made wide range of Art Nouveau silverware. Firm amalgamated with Orfèvrerie *Christofle in 1951.
Stamped mark.

CARTIER

J.C

Jewellers founded (1869) in Paris by Louis François Cartier, who was succeeded 1874 by son, Albert. By 1900, firm under control of Louis, Pierre and Jacques Cartier. Branches opened in London (1903) and New York (1912). Firm, associated in 1920s with stylish Art Deco pieces, produced more exotic, African-inspired jewelry in 1930s.
Stamped name and initials.

CAUSSÉ, Julien

Sculptor. Born in Bourges. Pupil of J. A. J. Falguière (1831-1900); exhibited at Paris Salon from 1888. Modelled bronze figures, mainly representing mythological or allegorical subjects.
Signature.

CAZIN, J. M. Michel (1869-1917)

Sculptor, ceramist, graphic artist, medallist. For biography see CERAMICS.
Moulded monogram.

CHALON, Louis

Sculptor. Modelled decorative pieces in base metal for mass-reproduction by E. *Colin & Cie.
Engraved signature and monogram.

CHAPLAIN, Jules Clément (1839-1909)

Sculptor, medallist. Studied at Ecole des Beaux-Arts in Paris. In Italy, 1864-68. Among founders of revival in art of medallion in France.
Engraved initials.

CHAPU, Henri Michel Antoine (1833-91)

Sculptor, medallist. Studied at Ecole des Beaux-Arts in Paris from 1849. In Rome, 1855-61. Made statues, portrait busts and medals.
Engraved signature.

CHARPENTIER, Alexandre (1856-1909)

Sculptor, medallist, artist-craftsman. Born in Paris. Studied under medallist H. *Ponscarme; exhibited at Paris Salon from 1879.
Engraved signature and monograms.

CHRISTOFLE, ORFÈVRERIE

Manufacturers of metalwork. Founded (1829) in Paris by partnership, Christofle & Calmette; continued independently by Charles Christofle (1805-63) from 1831. In 1840s bought monopoly in French

CHRISTOFLE

electroplate industry. Under direction, from 1863, of Paul Christofle (1838-1907). Installed in works at St Denis in 1875. Metalwork produced in 20th century to designs e.g. by J. *Olbrich, Jean Arp, Jacques Villon, Victor Vasarely, Gio Ponti.
Stamped marks.

COLIN, E., & Cie

E.COLIN&C⁼
PARIS

Metalworkers. Produced decorative metal objects after models by sculptors L. *Chalon, E. Lefièvre, etc.
Stamped mark.

COUDRAY, Marie Alexandre (b 1864)

ℂOUDRAY

Sculptor, medallist. Studied at Ecole des Beaux-Arts in Paris, under H. *Ponscarme.
Engraved signature.

DELBET, Pierre

Đ

Sculptor. Worked in Paris c1900; modelled bronze figures.
Monogram.

DUPUIS, Jean-Baptiste Daniel (1849-99)

ᗪANIEL ᗪVPVIS

Painter, sculptor, medallist. Studied at Ecole des Beaux-Arts in Paris, under H. *Ponscarme.
Engraved signature.

EPINAY DE BRIORT, Prosper, Comte d' (b 1836)

Ᵽ

Sculptor, jeweller. Studied in Paris and Rome; worked in Rome before settling (1880) in Paris. Made figurative jewelry.
Monogram.

FEUILLÂTRE, Eugène (1870-1916)

Sculptor, silversmith, Jeweller and enameller. Worked as enameller for R. *Lalique in late 19th century, setting up own workshop in 1899. Specialized in jewelry and *objets d'art* decorated with *plique à jour* enamel. Experimented in technique of enamelling on silver and later perfected application of enamel on

Feuillatre

platinum. Used combination of materials, e.g. gold, silver and glass, in jewelry (similar in style to work of Lalique) and Art Nouveau hollow ware. Exhibited at Paris Salon in 1899, Paris Centennial Exhibition (1900) and Turin International Exhibition (1902).
Engraved signature.

FONSÈQUE & OLIVE

Firm of jewellers working in Paris; produced wide range of Art Nouveau jewelry.
Stamped mark.

FOUQUET, Georges (1862-1957)

Gges Fouquet

G. FOUQUET

Goldsmith and jeweller. In 1891, joined Paris firm of father, Alphonse Fouquet (1828-1911); took control on father's retirement in 1895. Employed designers who included Tourrette, Charles Desrosiers and A. *Mucha, also producing own designs. Produced jewelry designed by Mucha for Sarah Bernhardt. Joined in firm by son, Jean Fouquet (b 1899).
Engraved signatures.

GAILLARD, Lucien (b 1861)

L Gaillard

L.GAILLARD

Silversmith and jeweller. Apprenticed (1878) to father, silversmith Ernest Gaillard (b 1836) and succeeded him (1892) in family firm. Silverwork shown in Paris Exposition, 1889. Concentrated on jewelry design from 1900, winning first prize at Paris Salon in 1904. Made extensive use of horn, ivory and unusual precious stones; influence of visit to Japan displayed e.g. in use of Japanese technique of mixed metals. Employed several Japanese craftsmen in Paris workshop.
Stamped marks.

GARNIER, Jean

J. GARNIER

Sculptor. Exhibited at Paris Salon, 1883-1905. Working in Paris, modelled bronze statuettes, vessels and portrait busts.
Signature.

GAUTRAIT, L.

L GAUTRAIT

Jeweller. Worked for Gariod firm in Paris c1900.
Engraved signature.

HIRNÉ

Hirnè.

Firm of Paris jewellers. Carried out designs by A. F. *Thesmar.
Stamped mark.

JANVIER, Lucien Joseph René (b 1878)

L.JANVIER

Sculptor, medallist. Pupil of J. A. J. Falguière and Antonin Mercié.
Stamped mark.

JOÉ-DESCOMPS, Emmanuel Jules (b 1872)

Artist-craftsman; worked in Paris.
Stamped mark.

LALIQUE, René (1860-1945)

 LALIQUE

Jeweller, silversmith, glassmaker, designer. For biography see GLASS.
Stamped marks.

LARCHE, Raoul (1860-1912)

RAOUL.LARCHE.

Sculptor. Pupil of F. Jouffroy and J. A. J. Falguière. Modelled decorative objects for reproduction in bronze and ceramics, notably statuettes of American dancer Loïe Fuller, produced in gilt-bronze.
Stamped signature.

LÉONARD, Agathon (b 1841)

A Leonard Sclp

Sculptor and designer. Studied at Lille Academy, then worked in Paris; modelled decorative statuettes for reproduction in bronze and porcelain.
Engraved signature.

PILLET, Charles Philippe Germain Aristide

Medallist; worked in Paris c1900.
Engraved signature.

METALWORK & JEWELRY

PONSCARME, Hubert (1827-1903)

 H·Ponscarme.

Sculptor, medallist. As teacher (from 1871) at Ecole des Beaux-Arts in Paris, influenced younger French medallists, e.g. A. *Charpentier, M. A. *Coudray, J.-B. *Dupuis.
Engraved signature.

ROBIN, Maurice, & Cie

Jewellers and silversmiths working in Paris.
Stamped mark.

ROCHE, Pierre (1855-1922)

Sculptor, medallist, painter, graphic artist. Pupil of Jules Dalou and Auguste Rodin. Collaborated with A. *Dammouse.
Stamped mark.

ROTY, Louis Oscar (1846-1911)

ROTY

Medallist. Worked in Rome 1875-78. Regarded as most prominent French medallist of late 19th century; like J. C. *Chaplain, contributed to revival of art.
Engraved signature.

RUDIER, Alexis

ALEXIS . RUDIER.

FONDEUR . PARIS.

Bronze foundry. Cast statuettes after originals by Antoine Bourdelle, Jules Dalou, Aristide Maillol, Auguste Rodin, etc.
Stamped mark.

SAINT-YVES

Arts and crafts designer. Work for La *Maison Moderne includes jewelry.
Stamped mark.

SIOT-DECAUVILLE

 SIOT-PARIS

Bronze foundry in Paris. Cast work for R. *Larche includes lamps, vases, inkwells, etc.
Stamped marks.

SIOT. FONDEUR. PARIS.

SPICER-SIMPSON, Théodore
(1871-1959)

Sculptor, medallist, printer, illustrator.
Born in Le Havre of English ancestry,
studied at Ecole des Beaux-Arts and
subsequently worked in Paris. Made
prolonged visit to USA.
Moulded initials.

SUSSE FRÈRES

Bronze foundry, active since 1840. Cast
work after originals by many noted
sculptors until 20th century.
Stamped marks.

THESMAR, André-Fernand
(1843-1912)

Artist-craftsman. Work, mainly in
enamels on jewelry and metalwork,
includes cloisonné enamel in Japanese
inspired style for *Barbedienne; later
specialized in *plique à jour* enamels.
Also decorated ceramics.
Monogram in cloisonné enamels.

THIEBAUT FRÈRES

Bronze foundry. Cast statuettes after
originals by Jules Dalou, Sarah
Bernhardt, J. A. J. Falguière, etc.
Stamped mark.

VALSUANI, C.

Bronze foundry. Cast works by Pierre
Bonnard, Antoine Bourdelle, Georges
Braque, Pablo Picasso, Paul Renoir, etc.
Stamped mark.

VERNIER, Séraphin Emile (1852-1927)

S. E. VERNIER

Medallist. Worked with various gold-
smiths. While visiting Cairo (1896-97),
studied Egyptian jewelry.
Engraved signature.

VEVER

VEVER PARIS

VEVER

Jewelry firm founded (1821) in Metz;
moved to Paris (1871). Firm directed
from 1881 by Paul Vever (1851-1915) and
Henri Vever (1854-1942). Among leading
Art Nouveau jewellers; executed designs
by E. *Grasset.
Stamped marks.

METALWORK & JEWELRY

VOULOT, Félix (b 1865)

$$V_o \cup L o \, t$$

Sculptor and engraver. Born in Alsace; lived in Paris, studying at Ecole des Beaux-Arts. Made decorative models for reproduction in metal and porcelain. Engraved signature.

YENCESSE, Ovide (1869-1947)

Ovide Yencesse

O YENCESSE

Sculptor, medallist. Studied at Dijon art school, and Ecole des Beaux-Arts in Paris. Principal of Dijon art school. Creator of many notable portrait medallions.
Engraved signatures.

WOLFERS, Philippe (1858-1929)

Sculptor, jeweller, metalworker, designer. Son of master-goldsmith Louis Wolfers. Studied sculpture under I. *de Rudder at Académie des Beaux Arts in Brussels before becoming apprentice in family firm Wolfers Frères, Belgian court jewellers. Work includes vases, bowls, etc. in naturalist style. 1897-1908: designed series of jewels, often incorporating stones engraved or carved with insects, human features, etc. Also designed ceramics.
Stamped mark.

DUTCH METALWORK & JEWELRY

AMSTELHOEK

Craft workshops. For details see CERAMICS. Workshops made silverware to designs by J. *Eisenloeffel. Stamped mark.

BEGEER, Cornelius

Silversmiths working in Utrecht and Amsterdam. Designers include Carel Joseph Anton Begeer (1883-1956) and J. *Eisenloeffel. Goods sold through De Woning. In 1925, firm joined with Van Kempen & Son in Voorschoten, with C. J. A. Begeer in charge. Stamped mark.

EISENLOEFFEL, Jan (1876-1957)

(i)

(ii)

Artist-craftsman. Born in Amsterdam. Studied as silversmith under W. Hoeker. Visited St Petersburg and Moscow. In 1896 became director of *Amstelhoek metal workshop. Worked with Amstelhoek for 't Binnenhuis (1900-01) and, from 1902, for De Woning, retail concern of which Eisenloeffel co-founder. Designs executed in silver by Van Kempen & Son. 1904-07: provided designs for Utrecht firm of C. *Begeer. Invited (1908) to work with Munich *Vereinigte Werkstätten für Kunst im Handwerk, but returned to Holland in same year, setting up own studio at Laren. Stamped marks on (i) silver, (ii) other metals.

ORANIA

Brand name for wide range of decorative pewter made in Netherlands c1900-1910. Stamped mark.

VAN DEN EERSTEN & HOFMEIJER

Jewellers and silversmiths of Amsterdam. Stamped mark.

BEHRENS, Peter (1868-1940)

Architect, painter, graphic artist, designer. Studied at Karlsruhe Academy and in Düsseldorf. In Munich from 1890, took part in Munich Secession (1893); co-founder of *Vereinigte Werkstätten für Kunst im Handwerk, 1897. In 1900, joined Matildenhöhe artists' colony at Darmstadt, and built own house there. Director of Düsseldorf art school from 1903. Chief designer to AEG electrical company from 1907. Taught in Vienna (1922-36), and subsequently in Berlin. Designed metalwork, ceramics, electrical appliances, graphics, etc.
Stamped mark.

BING, Gebruder

Proprietors of Nürnberger Metall-und-Lackierwaren Fabrik founded in 1895 at Nuremberg. Produced 'Bingit Zinn' pewter ware.
Stamped mark.

BOSSELT, Rudolf (1871-1938)

RUDOLF BOSSELT

Sculptor, medallist. Learnt metalwork in Berlin; studied at Kunstgewerbeschule, Frankfurt-am-Main, and Académie Julian, Paris. In 1899, joined artists' colony at Darmstadt. Subsequently held teaching posts at Düsseldorf, Magdeburg and Braunschweig.
Stamped and engraved marks.

BRANDSTETTER, A.

GUSS VON A. BRANDSTETTER MÜNCHEN

Bronze foundry in Munich.
Stamped mark.

BUDER & WIBRECHT

BUDER u. WIBRECHT

BLN FRIEDENAU

Bronze foundry in Berlin, active c1900.
Stamped mark.

CISSARZ, Johann Vincenz (1873-1942)

Painter, graphic artist, medallist,
designer. Studied at Dresden Academy.
Joined artists' colony at Dresden in 1903.
Subsequently taught in Stuttgart and
Frankfurt-am-Main.
Engraved signature.

DASIO, Ludwig

LVDW. DASIO

Sculptor, medallist. Studied at Munich
Academy. Visited Italy, Austria and
Paris. Work includes sculpture, medals
and art metalwork.
Engraved signature.

J. FRIEDMANN'S NACHFOLGER,
D. & M. Löwenthal

JFN

Jewellers and silversmiths of Frankfurt-
am-Main. Made jewelry after designs by
H. *Christiansen.
Stamped mark.

ELKAN, Benno (1877-1933)

Painter, sculptor, medallist. Studied at
academies in Munich and Karlsruhe.
Spent three years in Paris and Rome
before return to Germany.
Engraved initials.

ENGELHARD, Roland (1868-1951)

Sculptor, medallist. Studied in Berlin and
Vienna; subsequently worked in Hanover.
Moulded signature.

GAUL, August (1869-1921)

A.GAUL

Sculptor and graphic artist. Studied in
Hanau. Chief assistant to sculptor
Richard Begas from 1895. Modelled many
animal figures for casting in large
numbers in metal and pottery.
Engraved signature.

GEYGER, Ernest Moritz (b 1861)

E M. GEYGER

Painter, graphic artist, sculptor. Studied painting at Berlin Academy. From 1895, had studios in both Florence and Berlin. Modelled figures and ornamental articles for reproduction in bronze.
Engraved signature.

GLADENBECK, H., & Son

ARt-Ges. H. Gladenbeck & Sohn

Bronze foundry in Friedrickshagen, Berlin. Cast statuettes by M. *Klinger and other sculptors c1900.
Stamped marks.

GROSS, Karl (b 1869)

Sculptor and artist-craftsman. Studied at Munich Kunstgewerbeschule; taught at Dresden Kunstgewerbeschule from 1898. Pioneer designer of German art pewter in 1890s. Worked for L. Lichtinger, Munich. Also designed jewelry, furniture, etc.
Engraved signature.

HABICH, Ludwig (1872-1949)

Sculptor, medallist. Studied at Frankfurt-am-Main, Karlsruhe and Munich. In 1900 joined artists' colony at Darmstadt. Subsequently taught in Stuttgart.
Stamped monogram.

HAHN, Hermann (1868-1942)

H.HAHN

Sculptor, medallist. 1887-92: studied at Academy and Kunstgewerbeschule in Munich. After travelling widely, principally in Italy, settled near Munich.
Engraved signature.

HOETGER, Bernhard (1874-1949)

Sculptor, painter, architect. After working for firm of ecclesiastical decorators, studied at Düsseldorf Academy. After staying in Paris (1907-11) and Darmstadt (1911-12), settled in Worpswede (1914), visiting Italy and Egypt in 1924. Made statuettes in ceramics and bronze.
Engraved signature.

HUECK, Eduard

Firm of metalworkers. Founded in 1864 in Lüdenscheid, Westphalia. In 1899, under direction of Eduard and Richard Hueck. Produced pewter to designs by P. *Behrens, A. *Muller and J. *Olbrich.
Stamped mark.

KAYSER, JOSEF (SOCIÉTÉ DES BRONZES DE PARIS)

Bronze foundry in Hamburg. Cast statuettes by French sculptors for sale in Germany.
Stamped mark.

KLINGER, Max (1857-1920)

Painter, sculptor, graphic artist. Studied under K. Gussow in Karlsruhe and Berlin (1874-77). After periods spent in Paris, Berlin and Rome, settled in Leipzig. Made bronzes for reproduction.
Engraved signature.

KÖDDING, Johannes (b 1876)

Sculptor and medallist. Studied at Berlin Academy, 1897-1904. Joined Darmstadt artists' colony. From 1913, taught at Giessen.
Engraved signature.

LEYRER, C.

Bronze foundry at Munich. Cast statuettes after models by F. *von Stuck and other sculptors.
Stamped mark.

MAGNUSSEN, Harro (1861-1908)

HARRO MAGNUSSEN

Sculptor, medallist. Son of painter, Christian Karl Magnussen. Studied at Munich Academy; from 1887 assistant of Berlin sculptor, Richard Begas.
Engraved signature.

MORY, Ludwig

Munich pewter manufacturers. Founded in 1883. Designers included Rudolf Horrmann and Fritz Mory.
Engraved mark.

MULLER, Albin (1871-1941)

Architect, designer. Studied at Mainz and Dresden. Taught at Magdeburg, 1900-06; then joined Matildenhöhe artists' colony and became professor at Darmstadt technical high school. Designed pewter ware for firm of E. *Hueck.
Stamped mark.

OLBRICH, Josef Maria (1867-1908)

Architect, graphic artist, designer. Born in Austria, studied in Vienna, 1890-93; then travelled in Italy, Tunisia and France. Worked in studio of Otto Wagner, 1894-99. Founder member of Vienna Secession, 1897. In 1899, joined artists' colony at Darmstadt. Designed pewter for E. *Hueck, plated ware for C. *Schroeder and silver for Orfèvrerie *Christofle.
Stamped monograms.

ORION

Trade name for wide range of decorative pewter made in Nuremburg from mid 1890s.
Stamped mark.

ORIVIT

See SCHMITZ, F. H.

PAUSER, Joseph

J.P.

Silversmiths of Bremen. Manufactured cutlery designed by H. *van de Velde. Stamped mark.

PFEIFER, Felix (1871-1945)

FELIX PFEIFER

Sculptor, medallist. Studied at Leipzig Academy. Visited Berlin (1894-95), Rome (1895-96) and Paris; stayed in Dresden (1906-11), then worked in Leipzig. Engraved signature.

PÖLLATH, Carl

C.PŒLLATH

Foundry producing work in bronze and other metals at Schrobenhausen, Bavaria. Stamped mark.

RIEMERSCHMID, Richard (1868-1957)

Painter, architect, designer. Studied at Munich Academy. Co-founder of *Vereinigte Werkstätten für Kunst im Handwerk in Munich, 1897. Designed furniture, ceramics (for Reinhold *Merkelbach and *Meissen factory), typeface for German railways, and metalwork for Vereinigte Werkstätten für Kunst im Handwerk. Stamped monogram.

ROMER, Georg (1868-1922)

CR G.R.

Sculptor, medallist. Studied in Dresden, Berlin, Paris, Rome and Florence. Working in Munich, designed and made medallions. Engraved initials and monogram.

RÜCKERT, M. J.

RÜCKERT

Metalwork manufacturers of Mainz. Produced silver cutlery designed by P. *Behrens. Stamped mark.

SCHMITZ, Ferdinand Hubert

„ORIVIT"

Proprietors of Rheinische Bronze-geisserei at Köln-Ehrenfeld. Produced 'Orivit' pewter ware from 1901. Stamped mark.

SCHROEDER, C. B.

Firm of silversmiths working in Düsseldorf. Produced plated cutlery designed by J. *Olbrich.
Stamped mark.

SEFFNER, Carl (1861-1932)

Sculptor, medallist. Worked in Leipzig.
Engraved signature.

STURM, Paul (b 1859)

PAUL STURM

Sculptor, medallist. Studied at Academy of Graphic Art, Leipzig. Worked for Berlin Mint, 1908-19.
Engraved signature.

STROBL, A.

Metalworker. Worked for Munich firm of E. *Wollenweber.
Stamped monogram.

SY & WAGNER

SY & WAGNER.

Goldsmiths and silversmiths. Founded mid 19th century in Berlin by Emil August Albert Wagner (b 1826) and Francois Louis Jérémie Sy (1827-81). Firm produced decorative tableware in gold, silver and plate.
Stamped mark.

VAN DE VELDE, Henry Clemens (1863-1957)

Architect, artist-craftsman, designer. For biography see FURNITURE & TEXTILES. Designed range of cutlery, other domestic metalwork, and jewelry.
Stamped monogram.

VEREINIGTE WERKSTÄTTEN FÜR KUNST IM HANDWERK

Munich craft workshops. For details see CERAMICS. Made cutlery to designs by R. *Riemerschmid, etc.
Stamped mark.

VOGT, A.

Firm of metalworkers and jewellers at Pforzheim. Executed enamels after designs e.g. by H. *Christiansen.
Stamped mark.

METALWORK & JEWELRY

VON CRANACH, Wilhelm Lucas
(1861-1918)

Painter, designer and jeweller. Studied in
Weimar and Paris. From 1893, worked in
Berlin as portrait and landscape painter.
Jewelry, normally incorporated gold;
figurative in style.
Engraved monogram.

VON STUCK, Franz (1863-1928)

Painter, graphic artist, sculptor,
architect, designer. Studied in Munich;
founder member of Munich Secession,
1893. From 1895, taught at Munich
Academy. Modelled figures for
reproduction in bronze and ceramics.
Engraved signatures.

WENDE, Theodor

TH·WENDE

Silversmith of Darmstadt.
Stamped mark.

WERNER, O. M.

O.M.WERNER

Jeweller. Worked for family firm of J. H.
Werner, court jewellers in Berlin, *c*1900.
Stamped mark.

WILKENS, M. H., & SOHNE

Silversmiths of Bremen. Manufactured
cutlery designed by H. *Vogeler.
Stamped mark.

WOLLENWEBER, Eduard

E.D.WOLLENWEBER

Munich firm of jewellers and silversmiths.
Stamped mark.

WÜRTTEMBERGISCHE
METALLWARENFABRIK

 WMF B

Metalwork manufacturers formed in 1880
by amalgamation of Straub & Söhn,
Geislingen, and A. Ritter & Co.,
Esslingen. Produced wide variety of
decorative and domestic metalwork in
silver plate, nickel plate, galvanized
bronze, etc.
Stamped marks.

CZESCHA, Carl Otto (1878-1960)

Designer. Studied at Vienna Academy. Designed metalwork, furniture, etc., for *Wiener Werkstätte. In 1908 settled in Hamburg, taking post at Kunstgewerbeschule.
Monogram.

HAGENAUER WERKSTÄTTE

Metal workshops founded 1898 in Vienna by Carl Hagenauer (1872-1928). Son, Karl Hagenauer (1898-1956), joined firm in 1919 and took over management in 1928. Articles produced in wide·range of metals to designs e.g. by J. *Hoffmann and O. *Prutscher.
Stamped monogram.

HOFFMANN, Josef (1870-1956)

Architect, designer. Studied in Munich and Vienna; founder member of Vienna Secession in 1897. Taught at Vienna Kunstgewerbeschule, 1899-1941. Co-founder of *Wiener Werkstätte in 1903. Designed wide variety of useful and ornamental metalwork, as well as jewelry.
Stamped monogram.

HOSSFELD, Josef

Silversmith. Master silversmith working for *Wiener Werkstätte in early 20th century.
Stamped monogram.

KALLERT, Karl

Silversmith. Master silversmith working for *Wiener Werkstätte in early 20th century.
Stamped monogram.

KOCH, Konrad

Craftsman. Master craftsman working for *Wiener Werkstätte in early 20th century.
Stamped monogram.

KOUNITSKY, Franz (b 1880)

Medallist. Studied at Vienna Academy.
Worked at Vienna Mint.
Engraved signature.

KOWARZIK, Joseph (1860-1911)

Sculptor, medallist. Studied at Kunst-
gewerbeschule and Academy in Vienna.
Settled near Frankfurt-am-Main in early
1890s. Created small sculptures, plaques
and medallions.
Engraved signature.

KRUPP, Arthur

Firm of silversmiths in Vienna.
Stamped mark.

KURZER & WOLF

Jewellers and silversmiths in Vienna.
Stamped mark.

LIKARZ, Maria (b 1893)

L

Enamellist, designer. Studied at Vienna
Kunstgewerbeschule. Designed enamelled
jewelry, metal boxes, etc., for *Wiener
Werkstätte.
Initial mark.

MARSCHALL, Rudolf Ferdinand
(b 1873)

Medallist. Studied at Vienna Academy for
Decorative Art, 1896-98. Leading
medallist in Vienna from c1905.
Engraved signature.

MOSER, Kolo (1868-1918)

Painter, architect and designer. For
biography see CERAMICS. Designed
graphics, glass, ceramics and textiles as
well as metalwork and jewelry.
Stamped monogram.

PECHE, Dagobert (1887-1923)

Designer, decorative artist. For biography
see CERAMICS. Designed metalwork for
*Wiener Werkstätte.
Stamped mark.

PFLAUMER, Eugen

Master goldsmith working for *Wiener Werkstätte in early 20th century. Stamped monogram.

SCHEIDT, Georg Adam

Silversmith, jeweller and enameller. Working in Vienna c1900. Stamped mark.

SZANDRICK

Firm of silversmiths working in Budapest, Hungary. Stamped mark.

WESTELL ALLGAYER & Co.

Bronze foundry in Vienna, active c1900. Stamped mark.

WIENER WERKSTÄTTE

Craft workshops. For details see CERAMICS. Manufactured wide range of goods, including metalwork; designers include J. *Hoffmann, K. *Moser, D. *Peche and E. *Wimmer. Stamped marks.

WIMMER, Eduard Josef (1882-1961)

Designer and modeller. For biography see CERAMICS. Designed metalwork for *Wiener Werkstätte. Stamped monograms.

ZIMPEL, Julius (1896-1925)

Designer. Studied at Vienna Kunstgewerbeschule. From 1916 taught at training college for bookbinding and jewelry. Designed metalwork and jewelry for *Wiener Werkstätte. Monogram.

SCANDINAVIAN METALWORK & JEWELRY

BOLIN, W. A.

Jewelry manufacturers. Founded (1845) in St Petersburg by Swedish brothers, Charles and Henrik Bolin; later opened branches in Moscow and Germany. Produced costly, fashionable jewelry and operated as goldsmiths and jewellers to Russian Imperial court until opening of shop in Stockholm (1916); Swedish court jewellers to present day. Possessions in Russia lost, 1917.
Stamped mark.

HEISSE, C. F.

Silversmiths in Copenhagen, Denmark.
Stamped mark.

JENSEN, Georg (1866-1935)

Sculptor, ceramist, silversmith. Studied at Royal Academy in Copenhagen. Visited France and Italy. Made ceramics and opened unsuccessful porcelain workshops. Worked for jeweller from 1901 and opened own workshop (1904) in Copenhagen. From 1908, collaborated with painter, J. Rhode. Formed limited company, 1916; specialized in high quality, well designed silverware and silver jewelry.
Stamped marks.

MICHELSEN, A.

Jewellers and silversmiths in Copenhagen; founded in 1841. Executed designs e.g. by H. Slott-Müller.
Stamped marks.

SINDING, Stephan Abel (1846-1922)

Stephan finding

Norwegian sculptor. Studied art and philosophy at University of Christiana (Oslo), then sculpture in Berlin and Paris. Worked in Oslo, Rome, Copenhagen and, finally, Paris. Modelled figurative statuettes for reproduction in bronze.
Engraved signature.

FABERGÉ

(i)

(ii)

Goldsmiths and jewellers. Founded in St Petersburg by Gustav Fabergé, who was succeeded (1870) by P. C. *Fabergé. Received Imperial Warrant, 1881. Specialized in *objets de vertu*, using wide range of materials; Imperial Easter eggs produced from *c*1882. Branch opened in Moscow, 1887. Pieces produced by workmasters, e.g. A. W. *Holmström, M. E. *Perchin and H. *Wigström, who generally initialled work. Firm finally dissolved in 1918; goods confiscated by the Bolsheviks.
Stamped marks used at St Petersburg (i) and Moscow (ii).

FABERGÉ, Peter Carl (1846-1920)

Jeweller, goldsmith. Worked for family firm of *Fabergé from 1870.
Stamped mark.

HOLMSTRÖM, August Wilhelm (1829-1903)

Goldsmith and jeweller. Born in Finland. Went to Russia, setting up workshop (1857) in St Petersburg, and worked exclusively for *Fabergé; became firm's chief jewelry workmaster. Succeeded by adopted son, Albert (1876-1925), who continued to use father's mark.
Initials.

PERCHIN, Michael Evlampievich (1860-1903)

Goldsmith. Workmaster for *Fabergé from 1886. Responsible for all Imperial Easter Eggs made 1886-1903.
Stamped initials.

WIGSTRÖM, Henrik (1862-*c*1930)

Goldsmith. From 1886, chief assistant to M. *Perchin at St Petersburg branch of *Fabergé. Ran workshop from 1903 and continued production of Imperial Easter Eggs, etc.
Stamped initials.

GRAPHICS

BRITISH GRAPHICS

BEARDSLEY, Vincent Aubrey (1872-98)

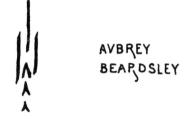

AVBREY
BEARDSLEY

Graphic artist, poster artist. Work published (1893) in *The Studio* regarded as major influence on contemporary graphic art throughout Europe and USA. Art editor of *The Yellow Book* (1894-95); appointed editor of *The Savoy* (1896). As well as designing posters, illustrated many books, including English translation of Oscar Wilde's play, *Salome*.
Printed signature and mark.

BEGGARSTAFF BROTHERS

Collaboration between graphic artists, poster artists, James Pryde (b 1869) and William Nicholson (1872-1949), brothers-in-law. Beggarstaff partnership noted for posters (especially those advertising Rowntree's Cocoa, and theatrical productions) and illustrated books.
Printed signature.

BRANGWYN, Frank (1867-1956)

Painter, graphic artist, designer. Largely self-taught, although helped by A. *Mackmurdo and Harold Rathbone. Employed as draughtsman by William *Morris & Co. Designed tapestries, carpets, and stained glass for Samuel Bing's Paris shop, La Maison de l'Art Nouveau. Also designed furniture and ceramics. Graphic art included posters and book illustrations.
Printed initials.

CALDECOTT, Randolph (1846-86)

Painter, graphic artist. Illustrated children's books; style inspired by Japanese prints.
Printed initials.

COOPER, Austin (b 1890)

Painter, graphic artist. Born in Canada, moved to Britain in 1896. Studied at Cardiff school of art. Returned to Canada, but settled in London (1922) and concentrated on poster design.
Printed signature.

CRANE, Walter (1845-1915)

Painter, graphic artist, designer. For biography see CERAMICS. Designed numerous children's books which were wood-block printed in flat colours.
Printed monogram.

DAVIS, Louis (fl c1885-c1920)

Graphic artist. Designed book illustrations and ornament.
Printed monogram.

ECKERSLEY, Tom

ECKERSLEY

Painter, graphic artist. Designed posters from c1930. Author of handbook on poster design.
Printed signature.

GERE, Charles March (1869-1957)

Painter, graphic artist. Studied painting at Birmingham School of Art. Designed illustrations and ornament for books, including works printed at William Morris's Kelmscott Press.
Printed monogram.

GREENAWAY, Kate (1846-1901)

K.G.

Graphic artist. Designed illustrations and ornament for numerous children's books, as well as calendars, greetings cards, etc.
Printed initials.

HARDY, Dudley (1866-1922)

Dudley Hardy

Painter, poster artist, illustrator. Studied at Dusseldorf Academy; visited Antwerp and Paris. Worked as illustrator for various London journals from 1886 and designed first poster c1890. Well known for *Gaiety Girl* posters.
Printed signature.

HAVINDEN, Ashley

Painter, graphic artist. Designed posters for many clients, including London Transport.
Printed signature.

IMAGE, Selwyn (1849-1930)

Painter, graphic artist, designer. Studied at John Ruskin's drawing school in Oxford. Close associate of *Century Guild, designed furniture, etc., produced by Guild, as well as illustrations and ornament for their periodical, *The Hobby Horse*.
Printed initials.

KING, Jessie Marion (1876-1949)

Designer, illustrator, bookbinder. Studied at Glasgow School of Art. Travelled on scholarship in France and Italy. Specialized in book illustration and jewelry design, also made hand-painted pottery and batik work.
Printed signature.

KNOWLES, Reginald L. (fl first half 20th century)

Graphic artist. Designed book illustrations and ornament, especially for publishers J. M. Dent.
Printed initials.

MACKINTOSH, Margaret Macdonald (1865-1933)

Designer. For biography see METAL-WORK & JEWELRY. Designed posters and graphic ornament.
Printed initials.

MACKINTOSH, Charles Rennie (1868-1928)

Architect, designer and decorator. Studied at Glasgow School of Art; travelled on scholarship to France and Italy, 1890. Designed furniture from c1890 for buildings built to own design. Leader of group of architects and designers, including wife, M. M. *Mackintosh, J. H. *McNair, J. M. *King, comprising Glasgow School;

influenced Vienna Secession.
Collaborated with wife on design of some
metalwork, wall panels, interiors, etc.
Also designed posters and graphic
ornament.
Printed initials.

McKNIGHT KAUFFER, Edward
(1890-1954)

Mckk

Painter, graphic artist, designer.
American, trained as painter in San
Francisco, Chicago and Paris; worked in
England from 1914. Designed posters
and book illustrations, murals, carpets,
tapestries, etc.
Printed initials.

PAINE, Charles

CPAINE

Graphic artist. Designed posters during
1920s and 1930s. Clients included London
Transport.
Printed signature.

SUMNER, Heywood (1853-1940)

HS

Graphic artist, designer. Designed book
illustrations and ornament,
wallpapers, etc.
Printed initials.

TAYLOR, Frederick (1875-1963)

FRED
TAYLOR

Painter, graphic artist. Studied at
Académie Julian, Paris, Goldsmiths'
College art school, London, and in Italy.
Designed posters.
Printed signature.

WHITE, Ethelbert (1891-1972)

Ethelbert White

Painter, graphic artist. Studied at St
John's Wood school of art, London,
1911-12. Designed numerous posters.
Printed signature.

BATCHEDLER, Ernest A.

Designer. Studied at Massachusetts Normal School, Boston, and School of Arts & Crafts in Birmingham, England. Contributed to *Inland Printer. iter.* Published *The Principles of Design* (1904). Taught at Throop Polytechnic Institute and Minnesota Guild of Handicrafts from 1904.
Printed initials.

BIRD, Elisha Brown (1867-1943)

· BIRD ·

Commercial artist. Studied architecture at Massachusetts Institute of Technology. By 1894, freelance contributor of decorative illustrations to several periodicals; also designed posters.
Printed signature.

BRADLEY, William H. (1868-1962)

·B·

Illustrator, poster artist. Self-taught, and primarily influenced by A. *Beardsley. Posters for *Chap-Book* and covers for *Inland Printer* established reputation in mid 1890s. Founded Wayside Press and published own magazine *Bradley: His Book*.
Printed initial and signature.

BRAGDON, Claude Fayette (1866-1946)

Architect, theatrical designer and commercial artist. Worked for Chicago publishers, Stone & Kimball in 1880s and 1890s.
Printed monogram.

CARQUEVILLE, Will (b 1871)

Will Carqueville

Commercial artist. Trained as lithographer in father's firm of Shobar & Carqueville. Designed posters for *Lippincott's Magazine* (1895-96). Studied in Paris *c*1900 and worked for *Chicago Tribune* after return to USA.
Printed signature.

GARNET, Porter

Book designer, illustrator. Worked in California *c*1905-*c*1930. Contributed to *The Lark*.
Printed monogram.

GOODHUE, Bertram Grosvenor

Painter, graphic artist. Co-editor and decorator (1892-93) of quarterly *Knight Errant,* which pioneered fine printing in USA.
Printed initials.

HAZENPLUG, Frank (b 1873)

Illustrator, poster artist, designer. Staff artist for Chicago publishers, Stone & Kimball.
Printed monogram.

HUNTER, David

Illustrator, graphic artist, book designer. Joined *Roycroft Shops at East Aurora, New York; designed books for Elbert Hubbard's Roycroft Press. Became expert on handmade paper and produced own books single handed.
Printed monogram.

LUNDBORG, Florence

Illustrator, graphic artist. Contributed to *The Lark* from its inception in 1895.
Printed monogram.

MOCINE, Ralph Fullerton

Painter, illustrator. Working *c*1900.
Printed monogram.

O'KANE, Helen Marguerite

Illustrator, book designer. Working *c*1900 in style influenced by English Arts & Crafts movement.
Printed monogram.

PARRISH, Maxfield (1870-1966)

Painter, illustrator, poster artist. Studied at Pennsylvania Academy of Fine Arts. Worked on graphic design of journals including *Harper's, Century, Scribner's* and *The Ladies Home Journal.* Designed posters from *c*1900.
Printed signature.

PENFIELD, Edward (1866-1925)

Commercial artist. Studied at Art Students' League. Art editor for Harper's periodicals 1891-1901.
Printed signature and monogram.

RHEAD, Louis (1857-1926)

Illustrator and poster artist. Born in England, studied at South Kensington School of Art, London. Settled in USA in 1883. Designed posters for *Scribner's* and *Century* magazines.
Printed signature.

ROYCROFT SHOPS

Craft community established in 1895 by Elbert Hubbard, designer, philanthropist and author. As well as making furniture and metalwork, shops made and published Hubbard's books, usually bound in soft chamois.
Stamped or printed mark.

SLOAN, John (1871-1952)

Painter, illustrator, graphic artist. Worked for *The Philadelphia Enquirer, The Echo* and *Moods.*
Printed signature.

WOODBURY, Charles Herbert (1864-1940)

Painter, poster artist. Studied at Massachusetts Institute of Technology and Académie Julian, Paris. Designed posters for *Century* magazine.
Printed signature.

ATCHÉ, Jean

Poster artist. Designed posters c1900 in style close to that of A. *Mucha. Worked in Paris.
Printed signature.

AURIOL, Georges (1863-1938)

Painter, graphic artist, designer. Member of 'Chat Noir' group of artists, which included T. *Steinlen and Willette. Work includes book ornament and calligraphy. Specialized in design of monograms, trade marks, seals and bookplates.
Printed monogram.

BERTHON, Paul Emile

Paul Berthon

Painter, poster artist, working in Paris c1900.
Printed signature.

CAPPIELLO, Leonetto (1875-1942)

Cappiello.

Cappiello

Painter, poster artist. Born in Livorno, Italy, naturalized French in 1898. Found greatest success as a poster designer in 1920s. Contributed to *Le Figaro, Gaulois, Le Rire, Assiette au Beurre,* etc., as well as designing posters.
Printed signatures.

CASSANDRE, Adolphe Mouron (b 1901)

A. M. CASSANDRE

Poster artist. Worked in Paris, adopting Cubist style, in 1920s. In 1930, founded Alliance Graphique.
Printed signature.

CHERET, Jules (1836-1932)

Poster artist, painter, modeller. Studied as lithographer in Paris, self-taught as artist. Visited England, and on return set up lithography studio, producing three-colour lithographs. In 1881, renounced control of press, but continued to design posters.
Printed mark.

GRAPHICS

COLIN, Paul (b 1892)

Poster artist, designer. Famous for designs for Le Ballet Nègre and Les Ballets Suédois. Worked for dancer and choreographer Serge Lifar.
Printed signature.

FAY, Georges

Poster artist. Worked in Paris, in the style of H. de *Toulouse-Lautrec, during 1890s.
Printed signature.

GESMAR, Charles (1900-29)

Graphic artist, theatre designer. Provided designs (including posters) for cabaret star, Mistinguett, in 1920s.
Printed signature.

GRASSET, Eugène Samuel (1841-1910)

Poster artist, illustrator, painter and artist-craftsman. Born in Lausanne, studied architecture in Zurich. After visits to southern France (Marseilles) and Egypt, settled in Paris in 1871.
Printed monogram.

JOSSOT, Henri Gustave (b 1866)

Illustrator, poster artist; also known as Abdul Karim. Born in Dijon, worked in Paris. Drew book illustrations, caricatures for periodicals, and posters.
Printed signature.

MISTI

Poster artist, probably pseudonym of Ferdinand Mifliez, lithographer born in Paris. Worked in Paris c1900.
Printed signature and monogram.

MUCHA, Alphonse Marie (1860-1939)

Painter, graphic artist, designer. Studied in Munich, Vienna and Paris. Achieved instant fame with poster for Sarah Bernhardt in play *Gismonda* (1894). Designed furniture, ceramic decoration, bronze statuettes, etc., as well as numerous posters.
Printed initial and signature.

PAL (b 1860)

Poster artist; pseudonym of Jean de Paléologue. Born in Bucharest, Romania, studied in London and Paris. Worked at Asnières (Seine). Early posters in England signed 'Julius Price'.
Printed signature.

PAUL, Hermann René Georges (1874-1940)

Poster artist, illustrator. Contributed to several French journals.
Signed work WPL or HP.

RIVIÈRE, Benjamin Jean-Pierre Henri (1864-1951)

Painter, graphic artist. Well known for series of lithographs, *Twelve Aspects of Nature, Breton Landscapes* and *Views of Paris*. Strongly influenced by Japanese woodcuts.
Printed initials.

STEINLEN, Théophile Alexandre (1859-1923)

Poster artist, illustrator. Studied at Ecole des Beaux-Arts in home town, Lausanne, Switzerland. Worked in Paris from 1882; contributor to *La Caricature, La Revue Illustrée, Le Rire,* etc.
Printed monogram.

TOULOUSE-LAUTREC, Henri de (1864-1901)

Painter, poster artist, illustrator. Studied at various ateliers in Paris. Keen student of Japanese prints, made first poster *Moulin Rouge* in 1891. Subsequently produced only 31 more poster designs.
Printed monogram.

VALLOTON, Félix (1865-1925)

Painter, graphic artist, poster artist. Born in Switzerland. Worked in Paris; associated with Nabis group of painters. Designed many lithographic posters.
Printed initials.

VERNEUIL, Maurice Pillard (b 1869)

Graphic artist, designer. Published books on European and Oriental design and ornament. Designed posters.
Printed monogram.

BERCHMANS, Emile (1867-1947)

Painter, illustrator, theatrical designer, poster artist. Studied at Liége Academy; with A. *Rassenfosse, A. *Donnay and M. Siville, co-founder of *Caprice Revue*. Designed numerous posters.
Printed signature and monogram.

CASSIERS, Hendrich (1858-1944)

Painter, illustrator, poster artist. Studied at Antwerp Academy. Designed posters and contributed illustrations to Belgian and foreign newspapers.
Printed signature.

COMBAZ, Gisbert (1869-1941)

Painter, illustrator, poster artist. Studied law, as well as taking courses at Royal Academy, Brussels. Orientalist, collector and writer, exhibited with La Libre Esthétique, 1897-1914.
Printed monogram.

CRESPIN, Adolphe (1859-1944)

Painter, theatre designer, poster artist. Studied in Brussels and in Paris. Close friend of architect, Paul Hankar. Designed posters from 1886. Taught at Schaerbeek, Brussels and Bischoffsheim.
Printed initials.

CRETEN, Victor C. J. (1878-1966)

Architect, painter, poster artist. Studied architecture at Royal Academy, Brussels. Varied architectural commissions include exhibition pavilions; many posters connected with same exhibitions.
Printed signature.

DELVILLE, Jean (1867-1953)

Painter, poster artist. Studied at Royal Academy, Brussels. Leading Belgian Symbolist painter. Participated in Salons de la Rose + Croix in Paris. Founded Salon d'Art Idéaliste in 1896. Taught at Glasgow School of Art 1900-07.
Printed monogram.

DONNAY, Auguste (1862-1921)

Painter, illustrator, theatrical designer, poster artist. Studied part-time at Liége Academy while working as house decorator. With E. *Berchmans, A. *Rassenfosse and M. Siville founded *Caprice Revue*. Illustrated work of Maurice Maeterlinck for *Mercure de France*. Exhibited with La Libre Esthétique, 1894-1901.
Printed monogram.

EVENEPOEL, Henri (1872-99)

Painter, illustrator, graphic and poster artist. Studied in Brussels and at studio of Gustave Moreau in Paris. Visited Algeria (1898-99) and died of typhus shortly after return.
Printed signature.

JORIS, Léontine (1870-1962)

Painter, caricaturist, poster artist. Daughter of doctor, had no formal artistic training; used pseudonym 'Léo Jo'. Contributed caricatures to *Le Rire, Lüstige Blatter* and *Simplicissimus*. Designed posters for La Libre Esthétique, sometimes taking part in group's exhibitions.
Printed signature.

LEMMEN, Georges (1865-1916)

Painter, graphic artist, designer, poster artist. As critic, interested in works of Georges Seurat. Exhibited with *Les Vingt* (1889-93) and La Libre Esthétique (1894-1912). Created original typeface for Leipzig edition of Nietzsche's *Also sprach Zarathustra* (1908).
Printed monogram.

LIVEMONT, Privat (1861-1936)

Illustrator, theatre designer, poster artist. Studied in Brussels and Paris. First poster, designed in 1890, followed by many more throughout career.
Printed signature.

MEUNIER, Henri Georges Isidore (1873-1922)

Illustrator, graphic artist, poster artist. Son of engraver and nephew of sculptor, Constantin Meunier, studied at Ixelles Academy near Brussels. First poster dates from 1895.
Printed signature.

MIGNOT, Victor (b 1873)

Painter, illustrator, poster artist. Began as illustrator for magazine *Le Cyclisme Belge*. After 1895, specialized in poster design.
Printed signature.

OTTEVAERE, Henri (1870-1944)

Painter, poster artist. Studied at Brussels Academy. Worked in Holland, England, Italy and southern France, as well as in Belgium.
Printed monogram.

RASSENFOSSE, Armand A.-L. (1862-1934)

Painter, illustrator, poster artist. Initially dealer in Oriental objects and curiosities, taught himself to draw at age of 30. Became close friend of F. *Rops, with whom experimented in printmaking. Exhibited with La Libre Esthétique between 1896 and 1914. With A. *Donnay, E. *Berchmans and M. Siville, founded *Caprice Revue*.
Printed monogram.

ROPS, Felicien (1833-1898)

Painter, graphic artist, poster artist. Travelled extensively in Europe, frequently to Paris; met poet, Baudelaire, in 1865 and studied printmaking under F. Braquemond and Jacquemart. Exhibited with Les Vingt from 1884. Graphic work often erotic in content.
Printed monogram.

STEVENS, Gustave-Mac (1871-1946)

G.M. STEVENS

Painter, poster artist. Studied at Brussels Academy. Exhibited with La Libre Esthétique. Designed posters from 1896. Printed signature.

VAN RYSSELBERGHE, Theo

Painter, poster artist. Artistic style dominated by contact with Georges Seurat. From 1886 until 1902, belonged to Les Vingt and exhibited with La Libre Esthétique, for whom designed posters. Printed monogram.

NIEUWENHUIS, Theodor Willem
(1866-1951)

T N

Designer, graphic artist. For biography
see CERAMICS. Working in Amsterdam
c1900, designed lithographs.
Printed initials.

SLUITER, Willy

Willy Sluiter—

Poster artist. Started to design posters
before World War I in flat, brightly
coloured style.
Printed signature.

TOOROP, Jan (1858-1928)

J.T.

Painter, designer, graphic artist, poster
artist. Brought up in Java, worked in The
Hague. Held leading position in
Netherlands school of Symbolist painters;
posters and graphics had wide influence
in 1890s.
Printed initials.

WENCKEBACH, L. W. R.

.L.W.R.
W.

Painter, graphic artist. Designed litho-
graphs, working in Amsterdam c1900.
Printed initials.

BEHRENS, Peter (1868-1940)

Architect, painter, graphic artist, designer. For biography see METAL-WORK & JEWELRY. Designed posters and illustrations.
Printed monogram.

BERNHARDT, Lucian (b 1883)

Poster artist. While still young, won competition for poster advertising matches. Quickly established as poster designer with style of simplicity, immediacy and strong colouring.
Printed signature.

CHRISTIANSEN, Hans (1866-1945)

Painter, graphic artist, designer. For biography see CERAMICS. Designed posters and book illustrations.
Printed monogram.

CISSARZ, Johann Vincenz (1873-1942)

Painter, graphic artist, medallist, designer. For biography see METAL-WORK & JEWELRY. Designed posters and illustrations.
Printed initials and monogram.

DEUTSCH, Ernst (b 1883)

Poster artist. Of Viennese origin, worked mainly in Germany, designing theatrical posters.
Printed signature.

ECKMANN, Otto (1865-1902)

Painter, graphic artist and designer. Among group of Jugendstil artists working in Munich in 1890s. Design motifs, like those of Hermann Obrist, based mainly on natural forms.
Painted monogram.

EDEL, Edmund (1863-1933)

Poster artist. Working in Berlin, designed posters, many for the theatre, in style derived from that of D. *Hardy.
Printed initials.

GRAPHICS

EHMKE, Fritz Hellmuth (b 1878)

Bookbinder, graphic artist; working in
Berlin c1900.
Stamped initials.

ERDT, Hans Rudi (1883-c1918)

HANS
RVDI
ERDT
°9

Poster artist. Worked in Munich and
Berlin.
Painted signature.

GRIMM, Richard (b 1873)

Painter, graphic artist. Working in
Düsseldorf c1900, active as book
illustrator.
Printed monogram.

GULBRANSSON, Olaf (1873-1958)

OLAF. G.

Painter, graphic artist. Well known for
caricatures of contemporary artistic
personalities in Munich, where he worked
c1900.
Printed signature.

HEINE, Thomas Theodor
(1867-1948)

Illustrator, graphic artist, poster artist.
Produced successful graphic designs from
mid 1890s, influenced by H. de
*Toulouse-Lautrec. Strong element of
grotesque and fantasy in work.
Contributed to *Simplicissimus,* etc.
Printed monogram.

HOHLWEIN, Ludwig (1874-1949)

LVDWIG :
HOHLWEIN
//
MUNCHEN

Poster artist. Trained as architect at
Munich Technical High School. Among
leading German poster designers of first
quarter of 20th century.
Printed signature.

JUNGHANS, Julius Paul

Graphic artist, illustrator, poster artist.
Working c1900.
Printed monogram.

KANDINSKY, Wassily (1869-1944)

Painter, graphic artist, poster artist. Studied painting in Munich and Paris after giving up job in Russian civil service. Created some of earliest abstract paintings and designed exhibition posters for Munich artistic groups Die Neue Künstler Vereinigung and Die Blaue Reiter.
Printed monogram.

KLINGER, Julius (b 1876)

J. KLINGER

Poster artist. Born in Vienna, worked for one year in Munich before going to Berlin. Reputation established by wit and elegance of posters designed before World War I.
Printed signature.

LUDWIG, Alois

Painter, graphic artist. Working in Düsseldorf c1900, active as book illustrator.
Printed monogram.

MOOS, Carl (b 1878)

Poster artist. Working in Munich, produced first poster in 1907. Specialized in sport and fashion posters.
Printed signature.

NEUMANN, Ernst (1871-1918)

Illustrator, graphic artist. Among leading designers of posters influenced by Jugendstil, which developed in Munich between 1890 and 1914.
Printed mark.

NIGG, F.

Graphic artist. Active as illustrator in Berlin c1900.
Printed monogram.

PAUL, Bruno (1874-1968)

Architect, designer, illustrator, graphic artist. Associated with *Vereinigte Werkstätte für Kunst im Handwerk, Munich; worked there 1893-1907. Designed furniture and glass; illustrated books.
Printed monogram.

SATTLER, Josef (1867-1931)

·**S**·

Painter, graphic artist, poster designer. Working in Berlin, designed several posters c1900.
Printed initial.

SCHEURICH, Paul (b 1883)

Scheurich

Painter, modeller, graphic artist, poster artist. Studied at Berlin Academy 1900-02. Prominent poster designer in Berlin; also modelled porcelain figures.
Printed signature.

STEINER, Jo

JO STEINER

Poster artist. Famous for cabaret posters designed in Berlin during 1920s.
Printed signature.

VOGELER, Heinrich (b 1872)

Painter, graphic artist, designer. Working with Worpswede artistic colony c1900, illustrated books, designed carpets, etc.
Printed mark.

VOLZ, Wilhelm (1855-1901)

Painter, graphic artist. Designed lithographs on symbolist themes, working in Munich c1900.
Printed monogram.

WITZEL, Josef Rudolf (b 1867)

I. R. W

Painter, graphic artist, poster designer, working in Darmstadt c1900.
Printed initials.

BEITEL, Karl

Bookbinder. Worked for *Wiener Werkstätte in early 20th century. Stamped monogram.

KLIMT, Gustav (1863-1918)

$$GVSTAV.$$
$$KLIMT.$$

Painter, graphic artist, poster artist. Studied at Vienna Kunstgewerbeschule. Co-founder and first president of Vienna Secession (1897); designed posters, and decorative wall panels in mixed media, notably for Palais Stoclet in Brussels (1905-09).
Printed signature.

ORLIK, Emil (1870-1932)

Painter, graphic artist, designer. Studied in Munich and Vienna (1903-04); worked as designer for *Wiener Werkstätee. From 1905 until death on staff of Berlin Kunstgewerbesmuseum. Designed book illustrations and posters.
Printed monogram.

PRUTSCHER, Otto (1880-1949)

Designer, poster artist. Studied at Vienna Kunstgewerbeschule. Worked for *Wiener Werkstätte, designing graphics, furniture, metalwork, ceramics, etc.
Printed monogram.

SCHUFINSKY, Victor (b 1876)

Poster artist. Taught at Institute for Tuition and Research in Graphics, Vienna, 1903-05. Worked in Vienna, designing several posters.
Printed monogram.

ITALIAN GRAPHICS

BISTOLFI, Leonardo (1859-1933)

Bistolfi

Sculptor, graphic artist. Working in Turin *c*1900, designed posters.
Printed signature.

BOMPARD, L.

LB

Painter, graphic artist. Working in Milan *c*1900, designed book illustrations and ornament.
Printed monogram.

DUDOVICH, Marcello (1865-1927)

D

Graphic artist. Contributed illustrations and ornament to several Italian and foreign periodicals. Well known for fashion posters.
Printed initial.

METLICOVITZ, Leopoldo (1868-1944)

LM

Graphic artist. Born in Trieste; after settling in Milan, designed posters and book ornament.
Printed monogram.

RUBINO, Antonio (1880-1964)

A RUBINO

Painter, graphic artist. Designed posters and book ornament, specializing in illustrations to children's books and magazines.
Printed signature.

TOFANO, Sergio

sto

Graphic artist. Worked in Milan in first half of 20th century, designing illustrations and ornament for books and periodicals.
Printed mark.

CLAVE, Antoni

clavé

Painter, poster artist. Worked in Barcelona in Cubist style reminiscent of paintings by Georges Braque. Particularly well known for film posters.
Printed signature.

DE RIQUIER, Alejandro

A de Riquer

Painter, poster artist. Worked in Barcelona; posters often in style influenced by E. *Grasset.
Printed signature.

RUSSIAN GRAPHICS

**AKIMOV, Nikolai Pavlovich
(1901-68)**

Theatre designer, poster artist. In 1918 worked at Proletkult poster workshop in Petrograd. From mid-1920s, designed posters mainly for own stage productions.
Printed initial.

**BORISOV, Grigori Ilych and
PRUSAKOV (b 1899)**

Poster artists. From 1924, Borisov specialised in film posters, often collaborating with Prusakov, fellow member of Young Artists' Society.
Printed combined signatures.

FAVORSKI, Vladimir

Illustrator, poster artist. Posters of 1920s reflect knowledge of work done in Vienna and Munich.
Printed monogram.

**KUSTODIEV, Boris Mikhailovich
(1878-1927)**

Painter, theatre designer, poster artist. Member of Mir Iskusstva (The World of Art) c1900; theatrical posters of 1920s well known.
Printed initials.

**LAVINKSY, Anton Mikhailovich
(1893-1968)**

ЛАВИНСКИИ

Theatre designer, poster artist. Worked mainly on posters during 1920s and 1930s.
Printed signature.

**ORLOV, Dimitri Stakheyevich
(1883-1946)**

D.MOOP

Illustrator, poster artist. Used pseudonym 'Moor'. Designed political posters c1917.
Printed signature.

**PAKHOMOV, Alexei Fyodorovich
(b 1900)**

Painter, graphic artist, poster artist. Illustrator of children's books, for which also designed posters.
Printed monogram.

RODCHENKO, Alexander Mikhailovich
(1891-1956)

Painter, architect, designer, poster artist.
Studied in art school at Kazan, Tatar.
Designed many posters in collaboration
with poet Mayakovsky. Used photo-
montage extensively.
Printed monogram.

STENBERG, Vladimir Augustovich
(b 1899) and Georgi Augustovich
(1900-1933)

Theatre designers, poster artists.
Brothers, who finished training at State
Fine Art and Technical Workshops in
1920. State designers for Vsevolod
Meyerhold and A. Tavov. From mid
1920s, collaborated on successful film
posters.
Printed mark.

FURNITURE & TEXTILES

BRITISH FURNITURE & TEXTILES

CENTURY GUILD

Group of designers and craftsmen formed c1882. For details see METALWORK & JEWELRY.
Initials incorporated in design printed on textile.

DORN, Marion

Textile designer. Born in America, worked in London in 1920s and 1930s. Married to E. *McKnight Kauffer. Rugs, designed to fit particular settings, made by Wilton Royal Carpet Factory.
Woven signature.

GRIERSON, Ronald (b 1901)

Graphic artist, designer. Designed rugs from 1930.
Woven initial.

JOEL, Betty (b 1896)

Designer. In 1920s, with husband, David Joel, established firm, Betty Joel Ltd., for production of furniture, light fittings, carpets, etc.
Woven monogram.

McKNIGHT KAUFFER, Edward (1890-1954)

EMCKK

Painter, graphic artist, designer. For biography see GRAPHICS. Designed carpets for Wilton Royal Carpet Co. from 1928.
Woven initials.

MORRIS, William, & Co.

Group of artists and craftsmen initially established as Morris, Marshall, Faulkner & Co. Members designed and made textiles, furniture, ceramics, stained glass, wallpapers, etc. Hand woven carpets made from 1878 at Hammersmith work-shop ('Hammersmith rugs') and subsequently at Merton Abbey.
Woven mark.

PEPLER, Marian (b 1904)

pEplEr

Architect, designer. Trained at
Architectural Association, London.
Designed rugs from 1930.
Woven mark.

AMERICAN FURNITURE & TEXTILES

ROHLFS, Charles (1853-1936)

Designer, furniture maker. Designed cast-iron stoves, and then made successful career on the stage. Afterwards turned to design and production of oak furniture; opened workshop at Buffalo, New York. Retired in mid 1920s.
Initial burned into wood.

YORK WALLPAPER Co.

Produced wallpapers at York, Pennsylvania, c1900 in style close to that of W. *Morris & Co.
Printed mark.

GALLÉ, Emile (1846-1904)

Glass-artist, ceramist, designer. For biography see GLASS.
Signature in marquetry.

LURCAT, Jean (1892-1966)

Painter and tapestry designer. Took up tapestry in 1915, while recovering from war wounds; in 1920s, made tapestries for French and American patrons. Adopted methods and materials of Middle Ages, c1930. Led group of artists, who included Joan Miró, in designing colourful, hand knotted rugs. Set up workshop in 1938 and abandoned painting (1939) to concentrate on tapestry. Throughout 1940s provided designs for weavers of Aubusson, near Lyons. Representational designs reflect interest in animal symbolism.
Woven initials.

BELGIAN FURNITURE & TEXTILES

VAN DE VELDE, Henry Clemens
(1863-1957)

Architect, painter, designer. Studied
painting at Antwerp Academy, and
Atelier Carolus-Duran, Paris (1881-83).
In 1894, designed building and furnishing
of own house near Brussels. Furnished
room at Samuel Bing's Paris shop, La
Maison de l'Art Nouveau, in 1896.
Settled (1899) in Germany and lived in
Weimar from 1901, at first as consultant
to Grand Duke, and then as head of
Kunstgewerbeschule (1906-15). Subse-
quently concentrated mainly on
architecture. As well as furniture,
designed ceramics and metalwork.
Stamped mark.

BURCK, Paul

Painter, graphic artist, designer, working in Munich c1900. Designed carpets. Woven initial.

ECKMANN, Otto (1865-1902)

Painter, graphic artist, designer. For biography see GRAPHICS. Designed carpets for *Vereinigte Smyrna-Teppich-Fabrike and wall hangings for Scherrebeker Kunstgewebschule. Woven monogram.

LECHTER, Melchior

Painter, designer. Working c1900, designed tapestries, furniture, stained glass and graphics. Woven monogram.

VEREINIGTE SMYRNA-TEPPICH-FABRIKE

Firm in Berlin, producing carpets c1900 to designs e.g. by O. *Eckmann. Woven initials.

VON GELDERN-EGMONT, Marie, Countess

Embroiderer; work includes hangings, cushion covers, table cloths, etc. in Berlin c1900. Stitched initials.

HEIDER, Ferdinand

Leatherworker. Head of the leather workshop at *Wiener Werkstätte. Stamped monogram.

KLIMT, Gustav (1862-1918)

Painter. For biography see GRAPHICS. Designed mixed media wall decoration. Monogram.

ORLIK, Emile (1870-1932)

Painter, graphic artist, designer. For biography see GRAPHICS. Designed intarsia panels, partly lacquered, for Vienna Secession exhibition. Monogram.

RODER, Adolf

Lacquer craftsman. Worked for *Wiener Werkstätte in early 20th century. Monogram painted in lacquer.

ROLLER, Alfred

Painter. Designed mixed media murals exhibited at Vienna Secession. Monogram.

TRETHAN, Theresa

Painter. Decorated furniture, etc. for *Wiener Werkstätte in early 20th century. Painted monogram.

HANSEN, Frieda (1855-1931)

Frida Hansɒn

Weaver. Born at Stavanger, Norway; learnt weaving in 1888. In 1890, founded studio for making of 'Hand-woven Norsk carpets', using traditional Norsk decorative motifs in designs. Carpets exhibited at Chicago World Exhibition (1893) and Universal Exhibition (1900) in Paris. Studied (1894-95) in Paris and Cologne.

Signature worked into design.

INDEX

INDEX